KISKA

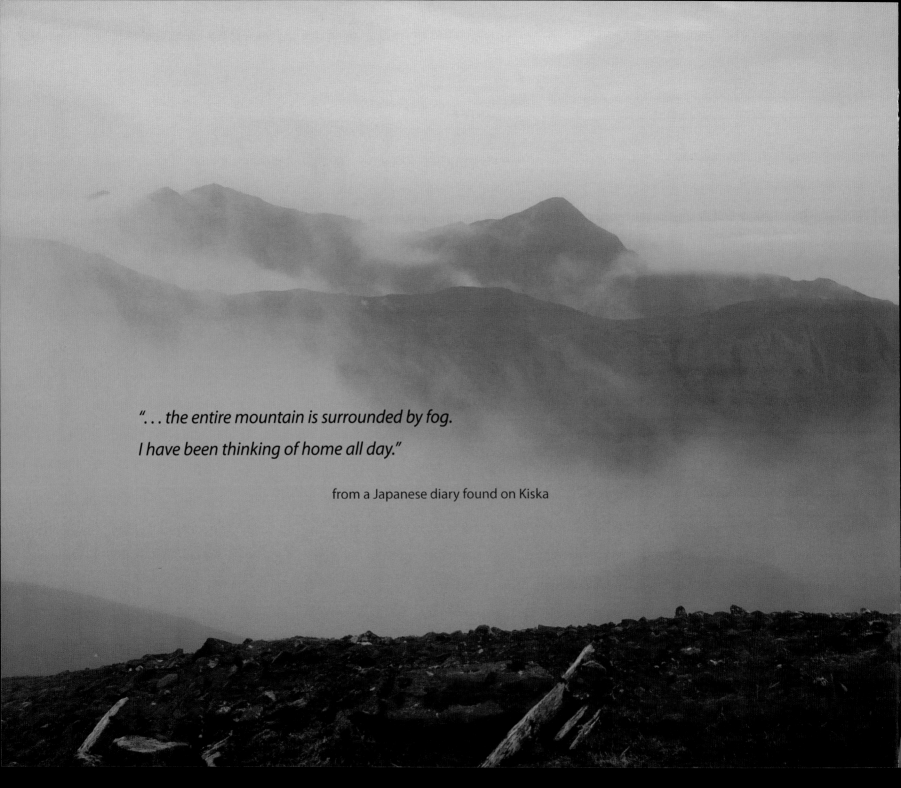

". . . the entire mountain is surrounded by fog.

I have been thinking of home all day."

from a Japanese diary found on Kiska

KISKA

The Japanese Occupation of an Alaska Island

Brendan Coyle

University of Alaska Press
Fairbanks, Alaska

University of Alaska Press
P.O. Box 756240
Fairbanks, AK 99775-6240

Library of Congress Cataloging-in-Publication Data

Coyle, Brendan, 1957–
 Kiska : the Japanese occupation of an Alaska island / Brendan Coyle.
 pages cm
 Includes bibliographical references.
 ISBN 978-1-60223-237-2 (hardcover : alk. paper)
 1. World War, 1939-1945—Campaigns—Alaska—Kiska Island. 2. Kiska Island (Alaska)—History, Military.
 3. Kiska Island (Alaska)—Description and travel. I. Title.
 D769.87.A4C688 2014
 940.54'28—dc23
 2014011923

Cover design by Dixon Jones.
Cover photo by Brendan Coyle.
Text design by Paula Elmes.

This publication was printed on acid-free paper that meets the minimum requirements for ANSI / NISO Z39.48–1992 (R2002) (Permanence of Paper for Printed Library Materials).

ALASKA
HUMANITIES
FORUM
Support for this book was provided
by the Alaska Humanities Forum
and by the Terris and Katrina Moore Endowment

SNOWY OWL BOOKS
an imprint of the University of Alaska Press

Printed in China

Contents

Foreword

The Aleutian Campaign of World War II, which lasted from June 1942 until August 1943, drove the Japanese from Attu and Kiska, two of Alaska's Aleutian Islands they had seized and fortified. The bloody battle of Attu cost the lives of 581 American ground troops and sixteen Army and Navy fliers; 2,350 Japanese died there.

Kiska, the subject of this volume, is a six-by-twenty-mile Aleutian Island nearly two thousand miles from mainland Alaska. It should be known for its beauty, lush summer vegetation, beautiful flowers, abundant berries, and a striking mountain at its north end. In summer the mountain supports uncountable nesting seabirds. As they wheel in unison, at a distance they can be mistaken for roiling smoke.

Unfortunately, this island is remembered with embarrassment by the military and news media for a battle that never took place. A carefully planned landing there by American and Canadian troops assaulted an island deserted by Japanese troops. During that landing American and Canadian troops mistook each other for the Japanese and opened fire; twenty-five Allied deaths resulted.

Forcing the Japanese to leave Kiska was a victory, and it should be celebrated as such. The Japanese fled Kiska days before our amphibious landing there, surrendering their toe-hold on the last piece of North American soil they had held.

PHOTO COURTESY OF ALASKA DEFENSE COMMAND ADVANCE INTELLIGENCE CENTER, NORTH PACIFIC COMMAND

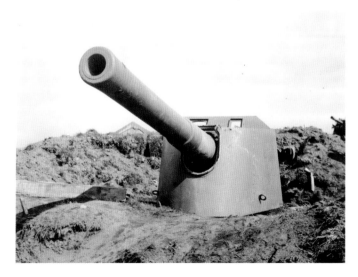

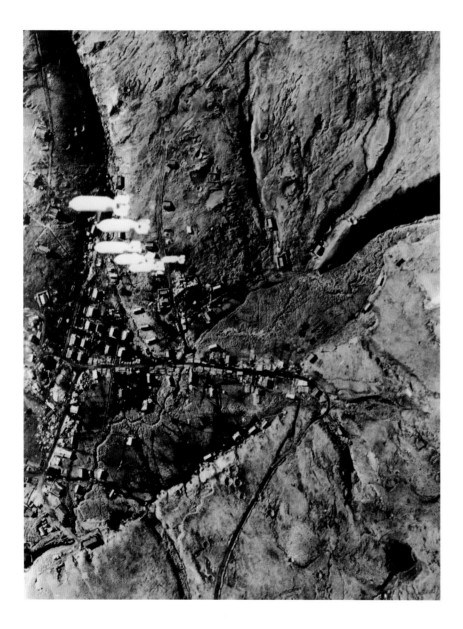

Establishing themselves on Kiska resulted in great loss of Japanese lives, aircraft, and ships as the United States responded to the only attack on North American soil during World War II: the Japanese landing on and fortifying of Attu and Kiska Islands.

For many months we bombarded a fortified area on Kiska with naval guns and aircraft. After the major air attack when our fighter planes and bombers assailed that island, American prisoner of war Charlie House, held by the Japanese at Kiska, counted four hundred boxes, each holding remains of a Japanese soldier killed in that raid.

If there are such, perhaps Kiska should be known for the abundance of ghosts, Japanese and American. The first of these would have been crews of our Navy PBY airplanes, which had foolishly been ordered to bomb Japanese naval equipment in Kiska Harbor. The huge, slow planes made an easy target for Japanese anti-aircraft guns.

Over the months of the campaign, at least five Japanese freighters and destroyers were sunk or badly damaged at Kiska. One of their navy submarines sank in Kiska Harbor after being struck by an American bomb.

Bombs from American bomber fall on a Japanese camp on Kiska. COURTESY UNITED STATES ARMY

When the Japanese landed on Kiska, they put twelve hundred troops ashore. There were five thousand Japanese troops on the island when they fled. They had installed heavy guns on the ridges around their main camp; dug at least fifty caves for storage, living quarters, a hospital, and shelter from air raids; and installed machine-gun pits and antiaircraft gun locations. At the head of Kiska Harbor they built facilities for mini submarines. When they secretly departed Kiska in July 1943, their hardware was left in place. The photographs in this volume make clear that much Japanese hardware is still found on that beautiful island.

After months of pounding Kiska with bombs, in July 1943, pilots of raiding American planes reported light or no antiaircraft fire for days on end. Two American fighter pilots landed on Kiska near the Japanese encampment and reported the place was abandoned. Stig Palm, skipper of a U.S. Navy minesweeper, sneaked his ship into Kiska Harbor and studied the area with binoculars. He too reported the Japanese had departed.

Despite these reports, officers in charge refused to cancel the amphibious landing. They remembered the bitter battle of Attu and the high American losses and justified going ahead with the Kiska landing by saying that even if the Japanese were gone it would be good practice to help the United States get ready for more landings; if the Japanese on Kiska had hidden themselves somewhere on the island, we would be prepared.

They were right in one sense. Lessons learned in the Aleutians proved helpful throughout the Pacific as we landed on islands closer and closer to Japan.

The Aleutian campaign drained Japan's war-making ability far more than it did that of the United States and Canada. The loss of men and hardware, including submarines lost when attempting to deliver goods to the beleaguered island and airplanes either shot down or lost to weather and the rough waters of Kiska Harbor, all took a heavy toll on the nation of the rising sun as it attempted to defend itself in Alaska, three thousand miles from its home islands.

Dr. Jim Rearden

summer grasses:

all that remains of great soldiers'

imperial dreams

Matsuo Bashō, Japanese poet, 1644–1694

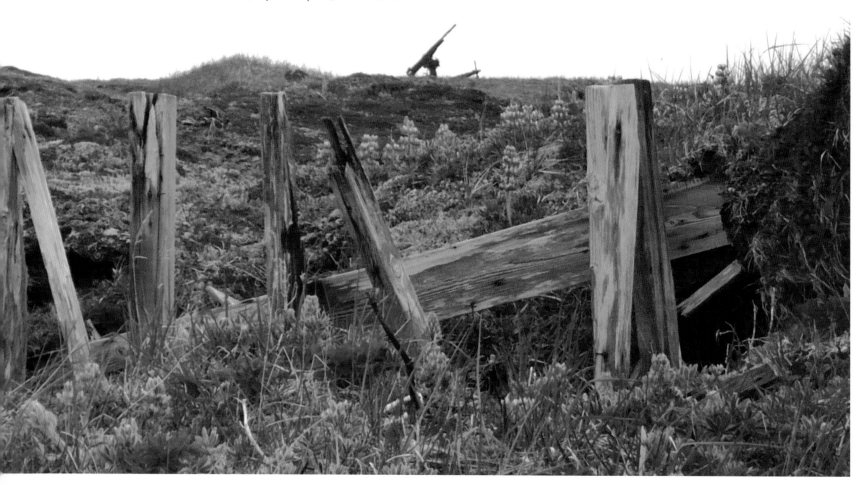

The island of Kiska is as beautiful as it is forebidding. Its verdant shores give way to bleak hills that rise quickly into fog, allowing me only fleeting glimpses of this subarctic terrain. The island is neither inviting nor accommodating. At the most northern end towers the brooding Kiska volcano, weeping rivulets of yellow, sulphuric vapor down its barren incline. The volcano is buttressed by Sirius Point, an ominous sea cliff of high wind, wheeling gulls, and waves thundering against its sheer rock face, forged when Kiska's molten lava flow was quenched in the icy Bering Sea. We glide past the broken bones of the *Borneo Maru*, once a Japanese ship, now slowly corroding away. The whole scene is oddly reminiscent of Jules Verne's *Mysterious Island*.

I had signed on as a field assistant to a biology professor[1] researching the effects of the Norway rat on the indigenous bird populations of Kiska and the western Aleutians. *Rattus norvegicus* was introduced to the Aleutian Islands by a Japanese seal hunting ship in the mid-1700s. World War II brought an increase of human activity to the islands. Japanese forces invaded Kiska on June 7, 1942, and a large American-Canadian force reoccupied Kiska in August 1943, conceivably accompanied by an increase in the rat populations. With little else to eat, the highly adaptable rodents devoured native bird eggs and chicks in the lowland marshes and cliff rookeries. Whole colonies of native Aleutian seabirds were lost on Kiska and other islands of the Aleutian chain as the rats proliferated.

My friends shook their heads in disbelief that I would forgo my summer to be perched on a barren island in the middle of the North Pacific, trapping voracious rodents. But I had long harbored a fascination with Kiska and the Aleutians. A part of the allure was the inaccessibility of the island itself. While the research paved my way, it was Japan's dubious World War II military foray into Alaska that drew me to Kiska. For me, the Japanese occupiers of Kiska had always been shadowy figures of this brief and most remote conflict of the Second World War. The United States responded to this enemy occupation of North American soil by moving massive amounts of resources into the sparsely populated Aleutians. Uninhabited islands were hastily peopled by thousands of servicemen building docks, bases, and

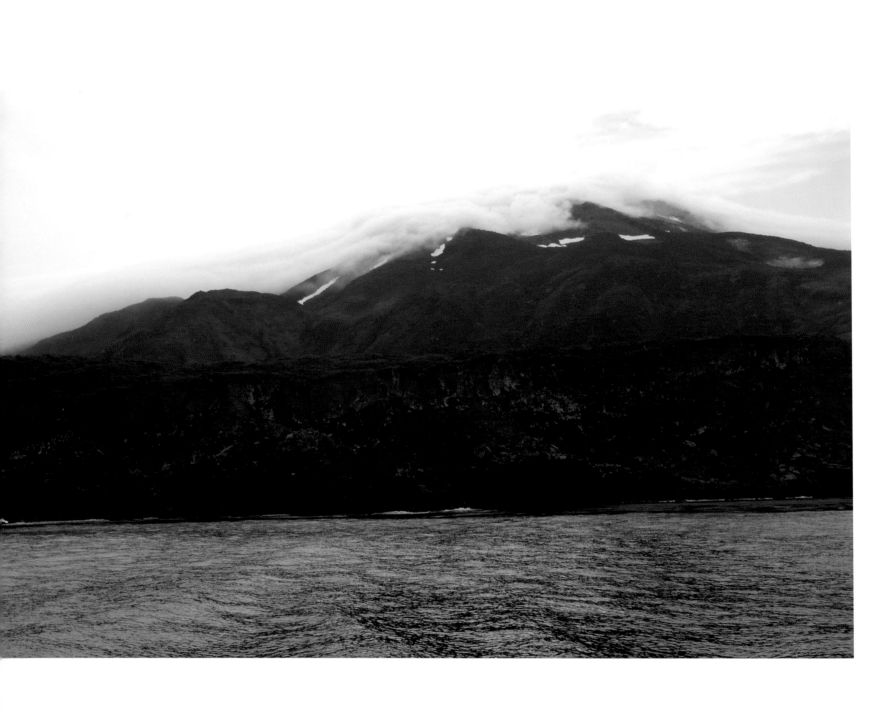

runways. Natural habitats were ravaged as the oceanic substrate ground cover was scraped away to bare rock, lagoons were drained and filled with gravel, and diversion systems were installed to drain marsh wetlands for airstrips and shore facilities. Aleut villages were burned to the ground to deny their use by the enemy while their populations of Alaska Natives were hastily uprooted to mainland internment camps.

The journey to Kiska took me over a week. Mount Redoubt, the active volcano on Cook Inlet 110 miles west of Anchorage, erupted five times in March of 2009, causing the cancellation of dozens of commercial flights in and out of Alaska. In early June it still threatened further eruption. I had confirmed plans to meet up with the U.S. Fish and Wildlife Service (USFWS) research vessel *Tiĝlax̂* (TEKH-lah) on Adak. With only two limited-space flights a week from Anchorage to Adak, any flight cancellation could scuttle my whole expedition. Dire warnings of further eruptions persisted into the summer but failed to materialize. After a night in Anchorage, where I picked up last-minute supplies, I boarded the modified Boeing 737 for the three-and-a-half-hour flight to Adak at the center of the Aleutian chain. There are

The Kiska volcano at Sirius Point.

no settlements beyond Adak, only the seasonal camps of scientists and university students involved in a wide and varied range of research. The U.S. Fish and Wildlife Service maintains an office on Adak, and it is the summer base of operations for *Tiĝlax̂*. I had six days on Adak Island before the ship picked me up for the trip out to Kiska, leaving me time to explore Adak, which itself has a storied past.

During the Aleutians campaign, Adak was the primary staging base against the Japanese. Infrastructure had been established on Adak to support large contingents of aircraft, navy ships, and personnel, while the western bases closer to the enemy remained fairly rudimentary. Due to its proximity to the Soviet Union, Adak was developed as a naval air station for submarine surveillance during the Cold War and accommodated six thousand servicemen and civilians. The navy closed the Adak base in 1997 and turned the town site and facilities over to the Aleut Corporation.[2] Currently there are about three hundred permanent inhabitants of Adak.

Adak had scant amenities. I was fortunate to be billeted at the USFWS bunkhouse. Luxuries came in the way of a dozen domestic beers for forty dollars and a bag of musty potato chips for seven dollars. Two University of California biology professors also waiting for a research ship invited me to accompany them in their Boston Whaler to conduct counts of marine mammals around

Adak. This allowed me to view Adak from the water and to visit the neighboring islands of Kagalaska, Little Tanaga, and Umak.

I made it a point to explore the abandoned Cold War base. At the site are a series of underground chambers built to bank-vault specifications with their own self-contained air supply. I had forgotten my flashlight, but my camera flash revealed an underground infirmary

and, for an instant, an unsettling snapshot of objects abandoned in the aftermath of an armed exchange: a white lab coat hung on the wall as if just left by its owner, boxes of biohazard suits, a pad of paper and pens at the desk, and a waste receptacle containing a crumpled brown lunch bag. An eerie silence pervaded, attesting to the dearth of human presence at the old base. After six days I was glad I would be boarding *Tiĝlax̂* in the morning to continue my journey to Kiska.

I was the only passenger on the *Tiĝlax̂* when I boarded on June 16 for the thirty-eight-hour trip to Kiska, including a stop at Buldir Island, sixty-five nautical miles west past Kiska, to pick up the professor. In true form, the Bering Sea was lake-calm water that turned to roiling troughs of green sea. Some 150 islands make up the Aleutian Archipelago, and because of the lesser isles that dot the chain between major islands it seemed to me that one *could* island hop between North America and Asia in a small boat the size of a kayak, in the manner of the original migrants.

At one point a sperm whale appeared off our starboard and paralleled our course for some time. The great black, toothed males live a solitary existence in the North

U.S. Fish & Wildlife service vessel *Tiĝlax̂* docked at Adak.

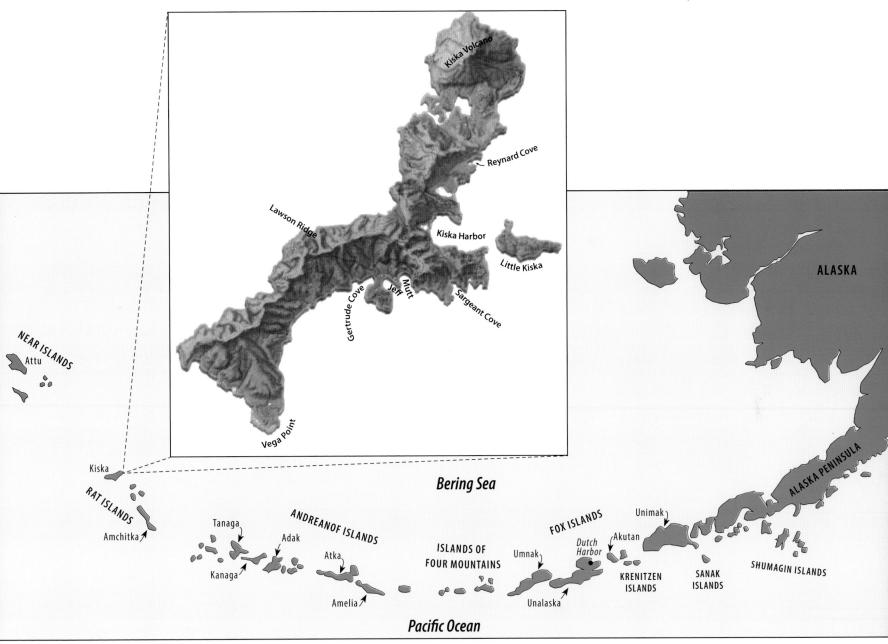

Kiska Volcano

Reynard Cove

Lawson Ridge

Kiska Harbor

Little Kiska

Gertrude Cove

Jeff

Mutt

Sargeant Cove

Vega Point

Bering Sea

Kiska

NEAR ISLANDS

Attu

ALASKA

ALASKA PENINSULA

RAT ISLANDS

Amchitka

Tanaga

ANDREANOF ISLANDS

Adak

Unimak

FOX ISLANDS

Akutan

Atka

Kanaga

ISLANDS OF
FOUR MOUNTAINS

Umnak

*Dutch
Harbor*

KRENITZEN
ISLANDS

SANAK
ISLANDS

SHUMAGIN ISLANDS

Amelia

Unalaska

Pacific Ocean

Pacific, only venturing south to mate with females that inhabit only the southern Pacific. We passed ominous Sirius Point, the most northern point on Kiska, to reach Buldir. Ten miles west of Kiska, the first officer pointed out the surreal Pillar Rock, a single barren column several hundred feet high in the middle of the ocean. This lonely corner of the earth reminds me of navigational charts of old, bordered with fanciful renderings of the great black whales, giant squid, and sea serpents, with ships of sail plummeting off the edge of a flat world.

The *Tiĝlax̂* inflatable boat crunched against the gravel shore, and two deckhands tossed our gear onto the beach. We were an expedition of only two people, dropped at our base camp at Gertrude Cove on uninhabited Kiska Island, three-quarters of the way to Siberia from the Alaska mainland, near the far western end of Alaska's remote and treeless Aleutian Archipelago. After decades of aspirations, I stood on Kiska's storied shore with mixed emotions. At fifty-two, it had been decades since I had left home and family for such a length of time. When I did, those sojourns had been brief compared to the nine weeks I would spend alone in the Aleutians, save for one other person. A quick handshake from the deckies, and they were gone. With a pang of apprehension I watched the skiff disappear into the fog, the resonance of the outboard motor fading into the distance. Other than

my compatriot, this departure would be my last human contact for some fifty days.

⸻

Kiska is unique among surviving World War II battlefields in that it remains relatively undisturbed. Public trespass, time, and nature have only slowly consumed the apparatus of war, although much evidence of the Japanese occupation was covered over or modified during the Allied occupation. We were strictly forbidden by the Alaska Maritime National Wildlife Refuge to dig for or remove objects, and for good reason beyond preservation of the artifacts: thousands of pieces of ordinance rest above and below Kiska's surface. Using modern satellite imagery and WWII maps for reference, we surveyed deep into the unexplored highlands of Kiska, a feat not done since the U.S. Geological Survey mapped the island in 1946 through 1951. Many of the geographic features of Kiska were unnamed, at least by Europeans, before World War II and only received formal designation on maps during planning for the Allied reoccupation. The coves Amos, Andy, Sargeant, Mutt, Jeff, and Gertrude

The freshwater stream at Gertrude cove. Our radio antenna is in foreground.

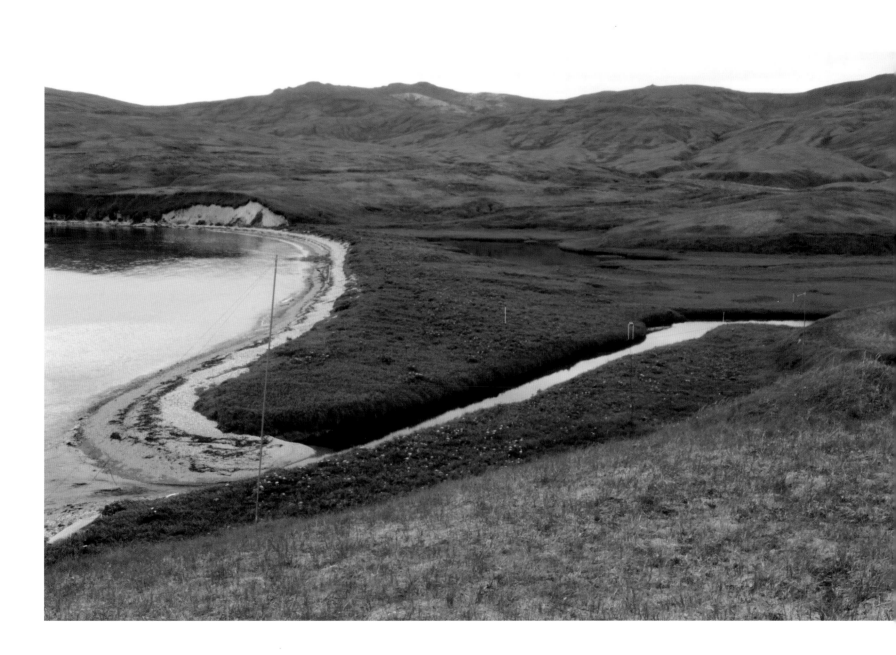

were all named for popular comic book characters of the time.

At Gertrude Cove, our camp life was reminiscent of that of the Japanese-Aleutian soldier, giving me the opportunity to experience their simple and harsh existence firsthand. Our base camp was situated next to a freshwater stream fifty yards up from the stony beach in the lee of a bluff. Directly above us was a well-hidden machine gun bunker built into the bluff by the Japanese.

Inside the bunker were the remains of a coal stove and the wood platform that a gunner would have used to position himself at the gun port. The bunker was supported by perfectly joined wood beams hewn in conventional Japanese form. Over the gun port a wood beam was inscribed with *kanji*, Japanese writing characters. Although barely legible, they referred to the month of June. The Japanese renamed Kiska as Narukami, a translation of *Narukamizunei,* which is one Japanese term for

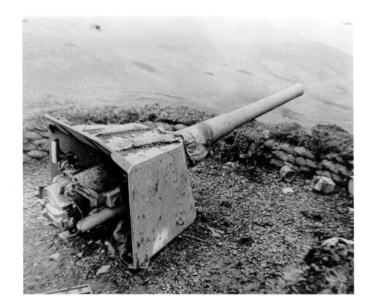
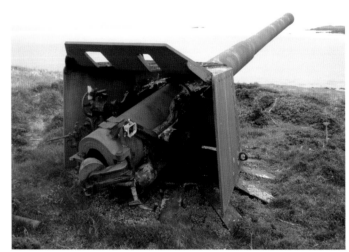

A six-inch coastal defense gun installed by the Japanese Imperial Navy at Kiska harbor. Left: 1943. Right: 2013. 1943 PHOTO COURTESY OF ALASKA DEFENSE COMMAND ADVANCE INTELLIGENCE CENTER, NORTH PACIFIC COMMAND. 2013 PHOTO COURTESY OF JOHN HAILE CLOE.

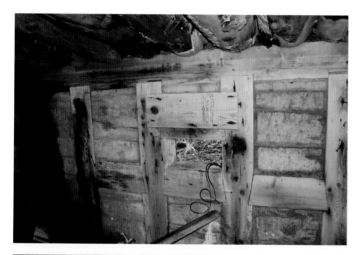

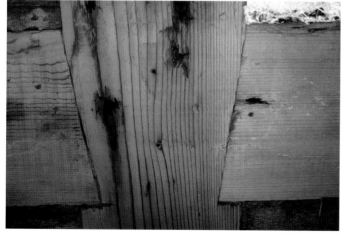

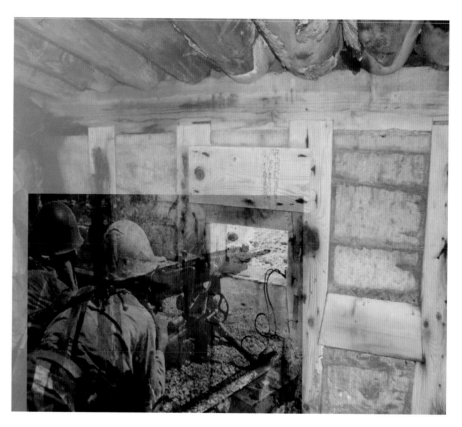

Above: This photo of a soldier on Guam is superimposed on the Kiska photo of the machine gun bunker. This gives an idea of how it would have been manned during the occupation. AUTHOR'S COLLECTION, PHOTOGRAPHER UNKNOWN

Above left: Japanese *kanji* characters written on the beam above the gun port refer to "June the 12th."

Middle and below left: Japanese style carpentry in post and beam construction.

the month of June, the same month the Japanese invaded Kiska. On bad weather days, I sometimes visited this bunker for a brief reprieve from the wind and rain.

When we arrived in mid-June there was still snow on the hills. I brought several versions of the "Alaska tuxedo": a full layer of nylon long johns, a layer of fleece, another fleece sweater, nylon cargo pants, and an outer layer of rain gear, depending on the weather. I brought three weights of hiking boots, a pair of Xtratuf gum boots, and sandals to wear in camp over layers of wool socks. For longer explorations of the island, we had to pack for every type of weather because it could change from rare sun to cold fog to freezing rain within a short time. Everything I had read of the Aleutian weather proved true. Perpetually overcast, the rain and sleet of summer was made even less endurable by the notorious williwaw, powerful winds that howl down the valleys to the sea. We packed extra food in our day packs in case we had to unexpectedly overnight away from camp due to the weather. The professor was skilled at orientation, and at times I was amazed that we made our way in blind fog safely back to camp.

Our main shelter consisted of a ten-by-eight-foot tent with a plywood floor. A kerosene heater kept me uncomfortably hot above the waist while my feet remained steadfastly cold—about a twenty-degree difference from head to toe and the same complaint of World War II soldiers. For power we had a small Honda generator with two car batteries, charger, and an inverter that kept cameras and laptop computers charged. A single seventy-five-watt bulb supplied our light. We each had

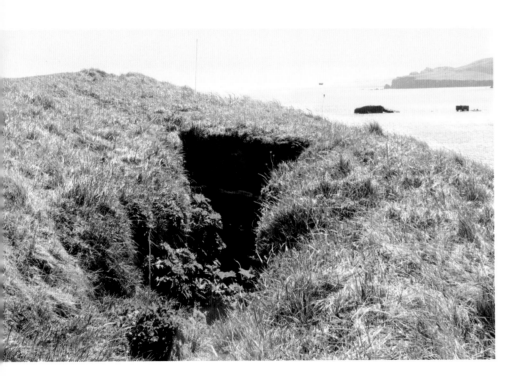

Entrance to a Japanese machine gun bunker at Gertrude Cove.

Right: Snow cave caused from melting snow.

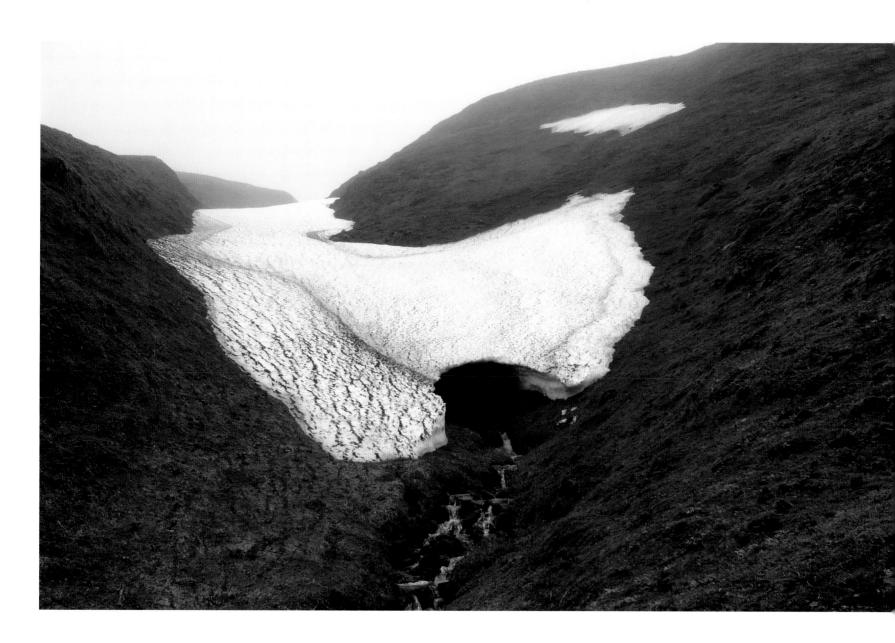

a Barney's Bomb Shelter, a tent designed specifically for the Aleutian climate. Really a tent within a tent, it had front and back vestibules and a covered perimeter for storage. The tent was lashed to stakes with a couple dozen tie-downs. I inadvertently pitched the tent over a chunk of iron protruding from the ground, and this caused my army-style cot to rock haphazardly, and leading to instances of stubbed toes accompanied by much swearing.

I laid down a bed of gravel from the beach around and between the tent walls to keep some of the mud at bay. It worked well, but the gravel contained sea lice, a type of arthropod that the rats savored, and they would rummage noisily between the tent layers in search of them as soon as the light went off. It was more annoying than unnerving to have a rat scrambling about with only the tent fabric between us. The camp had to be kept very clean due to the rat problem. We stored perishables in tight coolers and cleaned dishes immediately following meals. Because the temperature ranged from 55°F during the day to 40°F at night, there was no mold growth. Our bread was edible even after eight weeks.

We were both able cooks and made some fine meals on the dual-burner propane stove, including pizza and stir-fry. Canned meat with potatoes and vegetables made dinner the highlight of our day after long hours in the field. Our inventory consisted of much canned food, peanut butter, vegetables, potatoes, juices, canned meat and packaged items, rice and noodles, instant coffee, tea, oatmeal, chocolate, Pilot bread, and energy bars. We brought more food than needed for the projected

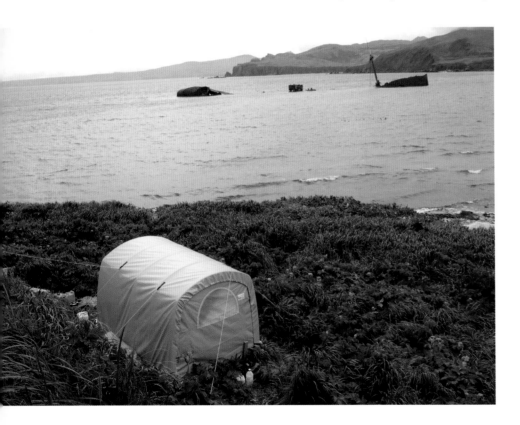

The main tent of our camp at Gertrude. *Borneo Maru* is in the background.

Arisaka Type 99 standard infantry rifle. PHOTO COURTESY LISA SPITLER, USFWS

duration of our expedition in the event a problem with our support vessel delayed our departure, so we never went wanting.

The refuse dump from a previous partial clean-up of the cove area was located near our camp. Alaska Maritime National Wildlife Refuge manager Robert D. Jones undertook a partial cleanup in the 1950s of war debris on Kiska, Attu, and Amchitka in an attempt to return the islands to a nature reserve. The dump location contained a mixed array of Nipponese guns and American cast-off material bulldozed into one location, including antiaircraft guns from a nearby battery of three Type 88 75 mm AA guns and one dummy gun. Another gun was situated on the hill behind our camp about 400 yards from shore. The retreating Japanese had ample time to remove the breech screws from the bigger guns and damage the rifling by jamming ordinance into the muzzles of the artillery pieces. Also in this clutter were the deteriorating frames of four Japanese right-hand-drive army trucks lying in state. A small but hardy winter wren darted in and out of the rusting truck bones, searching for food.

The Kamchatka rhododendron (*Rhododendron camtschaticum*) grows to only two inches high in the Aleutians.

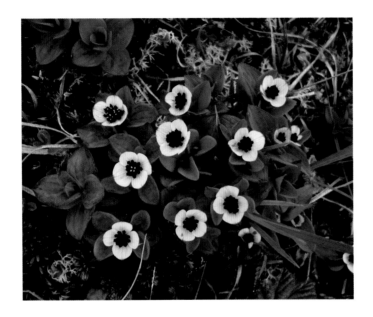

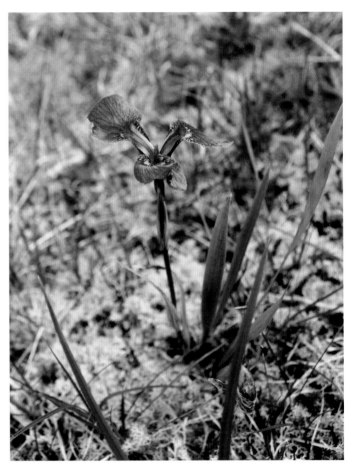

Above: Beachhead iris (*Iris seto*)

Top left: *Cornus suecia* with various lichens

Bottom left: *Primula cuenifolia* and *Gentiana aurriculata*

I expected the islands to be teeming with marine mammals but was disappointed to see just one otter and only a few seals during my stay on Kiska. Sea otters were transplanted back to Kiska and Amchitka by Jones in an attempt to reestablish otter colonies, but the effort achieved only limited success.

The water on Kiska is generally clean but because aquatic birds swim in the creeks and pools, we strained drinking water through a ceramic filter. In our first days we feasted on meals of king crab and halibut given to us by the cook on *Tiĝlax̂*, caribou steaks from the two University of California professors, and an eider duck that had drowned in the freshwater stream after getting tangled in a piece of drift net. Pink salmon accumulated at the stream mouth, and the professor tried his hand at fly fishing to no avail.

The stream that ran through camp was also the main source of fresh water for the Japanese, as evidenced by a series of small, hand-operated sluices. Within the stream we found intact fine bone china, rice and noodle bowls, and a sake cup. These china dishes were likely reserved for the officer class because of their ornate designs. The common soldier might have eaten out of his metal mess kit, but by 1942 shortages of nonferrous metal were already a problem for Japan. Metal food containers would have been a waste of precious aluminum. I found the lid of a Japanese kidney-shaped mess kit, but at the time I

mistook it for an American hospital dish. Other signs of the occupation included remnants of a Japanese gun manual; *tabi*, or traditional split-toed footwear; hobnailed leather and canvas boots belonging to peasant soldiers; a boar-bristle toothbrush with a tortoise shell handle; and canvas tent fragments. (We could discern

the white Japanese tent remains from the American drab green.) A mess tin, a faded book, clothing, tunnels, a coal stove, a sake bottle, spent cartridges—all bore quiet testimony to the lonely life of the Japanese soldier posted to Kiska.

As it was for me, the shortwave radio was a nightly diversion for the troops. Traditional Japanese music, dramas, and newscasts were broadcast from Japan, and the base would have been able to receive Russian and American transmissions as well. On my shortwave radio I was able to faintly pick up BBC Australia and Voice of Russia, so English-language broadcasts of Russian cultural airings such as *History of the Bolshoi Ballet* and selections of the great Russian composers such as Stravinsky and Tchaikovsky were imposed on my shallow knowledge of such refined culture.

Other nights I tuned in to the Japanese music broadcast on the shortwave band while the williwaw snapped at my tent. I could visualize the emperor's forlorn troops reflecting on home, huddled around the radio while those mournful Japanese tunes played. For us there was no internet or electronic media to squander away the hours. A single ten-minute phone call once a week on the satellite phone was the only connection to home. We received daily morning and evening radio calls from the USFWS office on Adak for safety and a weather report. The radio calls from the USFWS frequency KWL 45 Adak were heartening and allowed us some communication with camps on other islands. Due to atmospheric disturbance, sometimes camps on distant Bogoslof and Gareloi Islands were only garbled voices through an eerie static.

Qisxa

The first European sighting of Kiska Island was made by the Danish explorer Vitus Jonassen Bering during the Second Kamchatka Expedition. These voyages to explore the North Pacific were originally financed by the Russian Tsar Peter the Great. Eminent naturalist Georg Wilhelm Steller had been commissioned as botanist and physician for the Great Northern Expedition and made note of sighting Qisxa (the original Aleut name of Kiska):

> On 25 October 1741 we had very clear weather and sunshine, but even so it hailed at various times in the afternoon. In the morning we discovered to our astonishment to the north of us, on the 51st parallel, a large and high island.[3]

Historically, the saga of the Aleutians has been one of the overexploitation of the islands' resources and maltreatment of the indigenous populace. Distant relatives of the Siberian Yupik, the native Unangan/Unangas residents of the Aleutians have been speciously grouped together by the single term *Aleut*. The Aleut were expert hunters, fishermen, whalers, weavers, and sailors. Russian exploitation followed the discovery of the bounty in fur otter and marine mammals in the North

The remains of a sod structure, possibly an Aleut *barabara*. There are several of these structures on Kiska, some of which the Japanese used in their defenses.

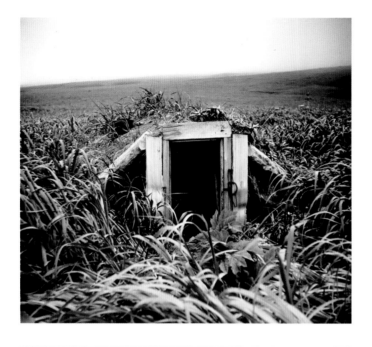

Pacific and Bering Sea. Aleut men were employed both freely and forcibly in hunting sea otters and later fur seals. Some Russian hunters held Aleut family members hostage to force Aleut men into hunting otters for the Russians. As the Aleut were hired or conscripted onto Russian fur hunting ships, traditional Aleut hunting periods were lost. At the onslaught of winter, some Aleut hunters were left to their doom on islands hundreds of miles away from home after missing their own season of subsistence hunting. For the Aleut community, the success or failure of the traditional hunting season was the fragile line between life and death.

In ungoverned Russian America, skirmishes between the cultures resulted in the deaths of either the Russian crews or the Aleut. Massacre Bay on Attu is so named for the murder of fifteen Aleut by Russian fur hunters in 1745. In 1763 the Aleut rebelled against Russian venturers on Unalaska, and four Russian ships wintering there were burned and their crews killed. The Russians responded

Top: Aleut *barabara* photographed during the 1936 Smithsonian Expedition to the Aleutians. PHOTO BY MALCOM J. GREANEY, COURTESY ALASKA STATE LIBRARY, HISTORICAL COLLECTIONS, ASL-MS251-01-05

Bottom: A *barabara* at Buhkti Point at Gertrude Cove on Kiska. PHOTO BY EWING GALLOWAY, COURTESY SMITHSONIAN INSTITUTION, WAR BACKGROUND STUDIES NO. 21 (FEB. 5, 1945)

by wiping out several Aleut villages on Unalaska. In May 1784 the Aleut staged a revolt on Amchitka after the fur enterprise ran out of goods used to pay the Aleut hunters. Several Russian traders were taken captive before the Aleut instigators were overpowered and killed. This odious association between Aleuts and Russians eased over time with intermarriage, the founding of the Russian Orthodox Church in Alaska, and the establishment of at least some governance.

Within a few short years, however, the otter—a mainstay of aboriginal existence—was pushed to the brink of extinction in the North Pacific, eroding a foundation of Aleut life. While Qisxa once had an established Aleut population, the permanent residents abandoned it during the period of the Russian-American fur empire. This was due in part to a consolidation of the fur industry in the eastern Aleutians and later the establishment of a commercial fur seal fishery far away in the Pribilof Islands. With the loss of the otter market, the Russian blue fox replaced otter as the cash crop throughout the Aleutians. Fox were transplanted to the islands where they were harvested for their fur under license to Russian-American fur trading companies. The Aleut, many now of mixed Russian blood, harvested a modest living from fox fur after the purchase of Alaska by the U.S. in 1867. The major crises of the outside world had little effect on the Aleut prior to 1941. The First World War, the Russian Revolution of 1917, and the Great Depression all came and went with little notice. Yet events unfolding in Asia would change the Aleut existence completely.

The Japanese invasion of the Aleutians forever changed the lives of the Aleut and fur trappers in the islands. The indigenous inhabitants of the western islands were forbidden to return to their traditional home islands following World War II. UNIVERSITY OF WASHINGTON LIBRARIES, FRANK H. NOWELL PHOTOGRAPH COLLECTION, NOWELL 4207

The Rising Sun

As early as the Russo-Japanese War (1904–1905), Japan sought to be the dominant power in Asia. This drive for supremacy was dictated by their mandate for the western Pacific Rim, the Greater East Asia Co-Prosperity Sphere. This policy professed the desire to create a self-sufficient bloc of Asian nations championed by Japan and free of Western colonial interference. While appearing altruistic, it contained a thinly veiled strategy for Japan's subjugation of Asia. This mandate of conquest was later extended to include Australia, Midway, and Hawaii in the south and Alaska's Aleutian Islands in the North Pacific.

Following this ideology, Japan launched an invasion of Manchuria in 1931 and then withdrew from the League of Nations following international condemnation of the occupation. The brutal subjugation of China began in 1937. Two years of border skirmishes ensued along the Manchurian–Mongolian border. This undeclared war with the Soviet-backed Mongolian army involved over 100,000 troops and the largest tank battle in history to that date. The conflict culminated in the Soviet rout of the Japanese at the Battle of Khalkin Gol in 1939 and

the signing of a tenuous nonaggression pact with Russia in 1941. Japan lost over eight thousand soldiers. Japan halted expansion to the north and west, looking instead to expand the empire into the Pacific and Southeast Asia.

Despite the proximity of the western Aleutians to Asia, the contention in the United States was that the islands would be of little value to the Japanese. The notorious williwaw winds regularly howled across the islands in excess of one hundred miles per hour, while dense fog and tempestuous seas were a constant bane. Nonetheless, Imperial Navy commanders feared the Aleutians could be used by U.S. forces as bases to attack Japan's Kurile Islands. Conversely they could be stepping stones to North America should imperial stratagem dictate a Japanese offensive. Control of western Alaska was intrinsic to Japan's ambitions and its security in the Pacific. Under the terms of the Washington Naval Treaty of 1922, the United States agreed not to fortify the Aleutians in order to allay Japanese fears over a possible American naval presence so close to the homeland. However, militarists within the Japanese Diet were not so easily appeased. Under the treaty's terms, Japanese naval

strength was limited to three-fifths that of either Great Britain or the United States. Japan renounced the treaty in 1934, paving the way to build all manner of warships. And at least some strategy for an occupation of Alaska had been envisaged prior to the war. Intelligence gathering, by navy personnel placed on Japanese vessels fishing in Alaska as well as other means, began in earnest in the latter part of the 1930s.

Japan's intentions in the Pacific came under scrutiny by an increasingly skeptical American press. In 1931, as a gesture of friendship and international goodwill, Japan announced a solitary flight by aviator Seiji Yoshihara from Tokyo to Washington, DC, and requested permission to station navy observers in the Aleutians along the flight path. Washington agreed, and a Japanese ship arrived at Attu and began charting the bays and harbors. The warship left shore crews at several islands while the Tokyo plane reported setback after setback. After two crashes, the Tokyo–Washington trip was cancelled, and the Japanese ship retrieved the shore parties after three months of gathering hydrographic information. While Yoshihara's exploit itself was likely innocuous, it raises

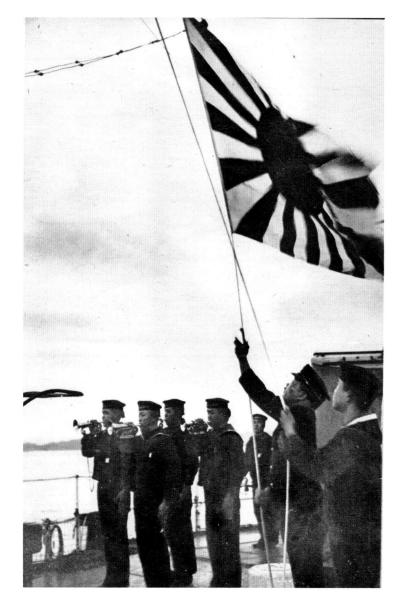

The Rising Sun ensign is run up the mast on a Japanese warship in Kiska Harbor in the first days of the occupation.
DAITOUA

the question of whether the Imperial Navy's support was in fact a clandestine endeavour for charting the Aleutians.

Further actions by the Japanese in Alaska only consolidated this sentiment within the Western media. Following alleged repeated territorial violations, in 1938 the *United Press* called the Japanese fishing fleet in Alaska "a highly effective instrument for espionage."

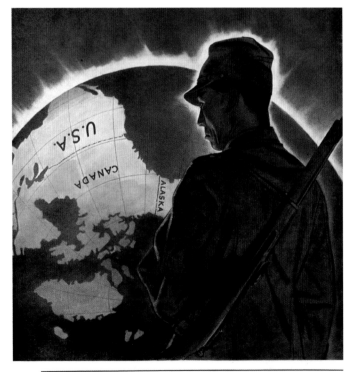

CONSOLIDATED VULTEE AIRCRAFT

Under the guise of fur seal management, the Japanese fisheries research vessel *Hakuho Maru* frequently visited the Aleutians. Helen Wheaton, an American author who ran the general supply store in the Aleut village on Atka, described how the *Hakuho Maru's* captain and crew, resplendent in their uniforms, requested permission to take on fresh water at Nazan Bay. For three days the ship re-watered, a process that should only have taken a few hours; all the while the crew sounded Nazan Bay.[4]

In November 1941, just before the attack on Pearl Harbor, Frank Daugherty, the Bureau of Indian Affairs teacher at Gambell on St. Lawrence Island made a startling report to U.S. Army officials. A landing party had come ashore from a Japanese vessel for unspecified purposes and stayed for several days. The ship then departed to the east but left behind a shore party. The ship's detail continued to scout the island until picked up two weeks later when the vessel returned. These and similar incongruous actions by the Japanese only reinforced the belief of many Alaskans that Japan was priming to invade American territory.

Reaction to Japan's occupation of Kiska tended to be sensationalistic, as portrayed in this 1943 advertisement for the Vultee Aircraft Company, which depicts a Japanese soldier eyeing North America. CONSOLIDATED VULTEE AIRCRAFT COMPANY

December 7, 1941: A Clash of Titans

In 1935, Brigadier General Billy Mitchell predicted war with Japan and that Alaska would be key to the whole Pacific when that eventuality occurred. Every major city in the Northern Hemisphere is within 5,100 miles flying distance from Anchorage. Mitchell also believed that naval air warfare was a development whose time had come. He was a proponent of a strong fleet built around the aircraft carrier, replete with highly trained aircrews.

This thinking was shared by Admiral Isoroku Yamamoto, Japan's premier naval strategist and supreme commander of the Imperial Navy. He too believed the aircraft carrier would be the dominant surface vessel in any modern navy. The United States already possessed a number of carriers and based a sizeable carrier group at Pearl Harbor in Hawaii, a resource that would need to be eliminated if Japan was to continue her path of conquest in the Pacific.

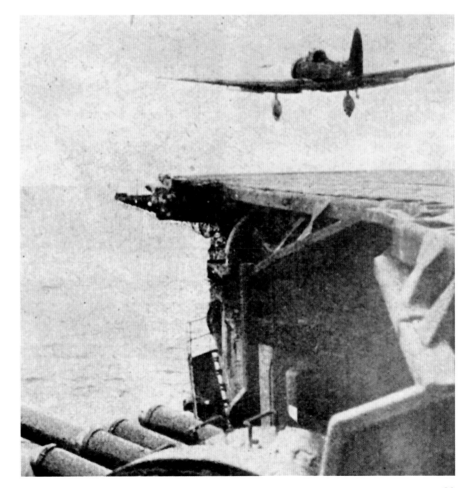

A Japanese plane lifts off a carrier deck in the Battle of Dutch Harbor, June 3–4, 1942. *DŌMEI TSŪSHINSHA*

The Aleutians Theater, 1942–1943

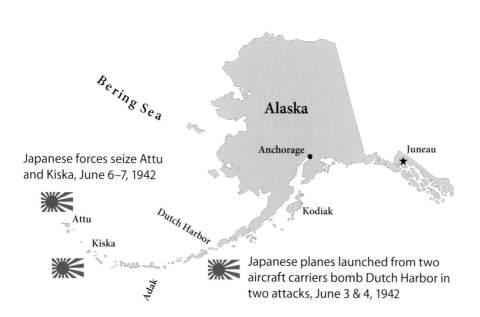

Japanese forces seize Attu and Kiska, June 6–7, 1942

Bering Sea

Alaska

Anchorage

Juneau

Attu

Kiska

Dutch Harbor

Kodiak

Adak

Japanese planes launched from two aircraft carriers bomb Dutch Harbor in two attacks, June 3 & 4, 1942

On December 7, 1941, as Pearl Harbor was under attack by Japanese carrier-launched planes, the intended targets—the American carriers of the Pacific Fleet—were away from the base on various duties. The attack on Pearl Harbor resulted in the permanent loss of two American battleships and one auxiliary vessel but left the U.S. Pacific carrier fleet intact. This was not the victory Yamamoto had envisioned. With this turn of events, Yamamoto initiated a strategy to draw out and destroy the American carriers. An attack on Alaska, at Dutch Harbor in the eastern Aleutian Islands, would draw the U.S. fleet north where they would be surprised at Midway, 1,140 nautical miles northwest of Hawaii, and destroyed by numerically superior Imperial Navy carriers.

The Japanese plan originally called for a diversionary attack on Dutch Harbor followed by the occupation of Adak Island, halfway down the Aleutian chain, and Kiska and Attu in the western Aleutians. For Yamamoto, the simultaneous Midway and Aleutian actions would achieve several goals: the destruction of the American aircraft carrier fleet; the occupation of the Aleutian Islands, thereby denying their fortification by U.S. forces; and the occupation of Midway, where a perimeter extending from the Aleutians through Midway to Fiji would be established, leaving Hawaii vulnerable to further action. Conceivably, this captured Alaska territory could then be used to either negotiate a peace or launch attacks against North America should the United States not wish to talk.

War Comes to Alaska

Dutch Harbor is situated on Amaknak Island, eight hundred miles west of Anchorage. It is the gateway to the Bering Sea and the center of the commercial bottom fish and king crab fisheries. In 1942 it was a remote fishing village with a population of less than four thousand, mostly made up of indigenous Alaskans. In response to the Japanese sabre rattling, the United States was nearing completion of a naval anchorage, submarine depot, and the Fort Mears army base at Dutch Harbor. In consecutive attacks on June 3 and 4, 1942, the village was bombed by aircraft from the carriers *Ryujo* and *Junyo* of Rear Admiral Kakuji Kakuta's Second Carrier Striking Force. Thirty-four Americans were killed in the initial attacks, the army base took a direct hit on a barrack, and a gun position on Mount Ballyhoo was destroyed. The oil tank farm was hit and burned, spewing inky black smoke into the sky for several days. The SS *Northwestern*, an Alaska Steamship Company vessel appropriated by the army for use as a floating construction camp, took a direct hit and burned fiercely in the harbor, while the

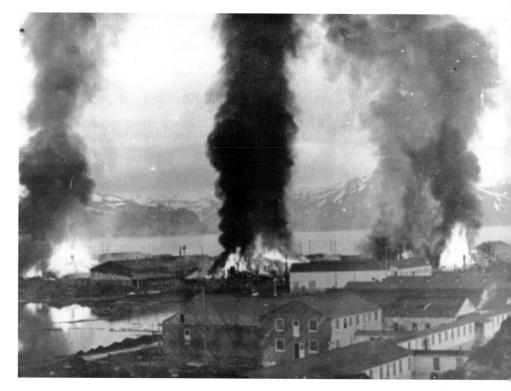

Dutch Harbor burns following Japanese aerial attacks June 3 and 4, 1942. PHOTO HAROLD COPPIN

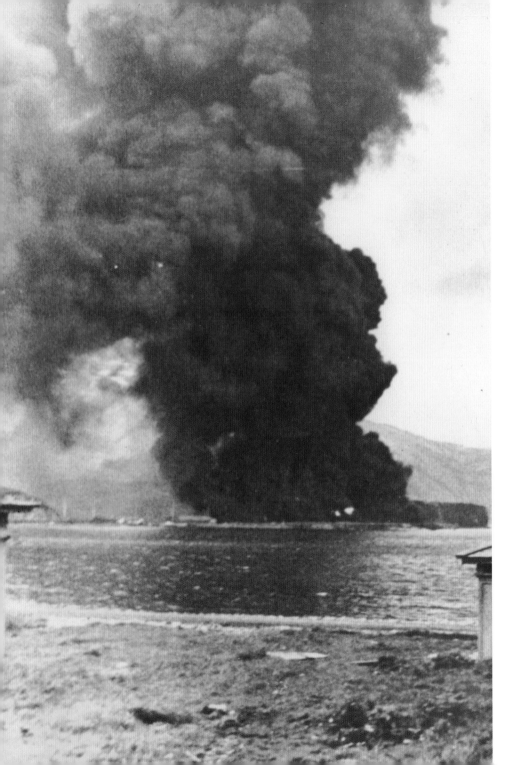

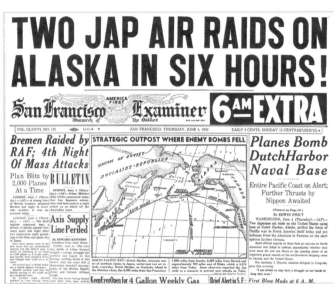

Left: Dutch Harbor burns following Japanese aerial attacks June 3 and 4, 1942. PHOTO HAROLD COPPIN

Above: Headline courtesy of *San Francisco Examiner* newspaper, Todd Vought, publisher.

hospital at Unalaska had its side blown off from a stray bomb. Another forty-seven airmen died in pursuit of the enemy carrier force, and the Japanese took three Americans prisoner. Despite these actions, the attacks on Dutch Harbor did not achieve the Japanese goal of drawing the American carrier fleet north. The Americans had broken the Japanese naval code and knew the enemy fleet was heading to Midway. The Imperial Navy lost four major aircraft carriers at Midway. The sinking of *Akagi, Hiryu, Kaga,* and *Soryu* was a defeat from which the Japanese navy would not recover.

With the huge loss of such critical naval resources at Midway, Imperial Navy planners quickly recognized the untenable nature of a supply line stretching from Asia halfway to Alaska in the inclement North Pacific. Admiral Yamamoto wanted to forgo the Aleutian operation but was convinced that the occupation of the western Aleutians, led by Rear Admiral Boshirō Hosogaya, commander of the Fifth Fleet/Northern Area Force, should proceed in order to prevent the Americans from utilizing the Aleutians. The plan was quickly refocused to only

occupy Kiska, 1,190 nautical miles west of Anchorage, and Attu, 180 miles farther west. To save face, Nippon news made no mention of the defeat at Midway but boasted of their strikes on Dutch Harbor. Indeed, most Japanese citizens only learned of the Midway defeat and of those killed there after the end of the war.

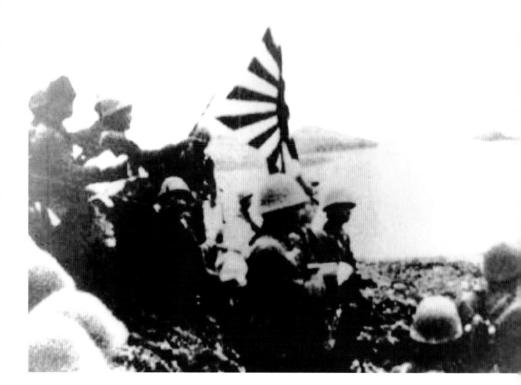

Naval landing force troops of the Imperial Navy land in the Aleutians. June 6 or 7, 1942. *DAITOUA*

Invasion of the Aleutians

On June 6, Imperial Army soldiers occupied Attu Island after landing at Holtz Bay at 21:30 and making their way south to the Aleut village at Chichagof

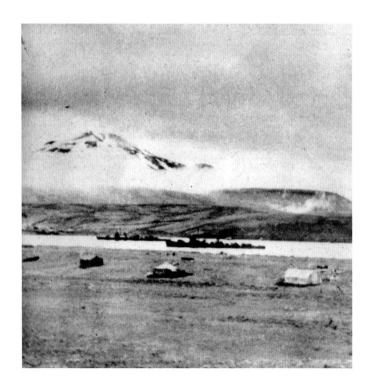

Harbor. The forty-three Aleut citizens living on Attu were removed and interned at Otaru on the Japanese island of Hokkaido, where the able-bodied did menial work for the equivalent of ten cents per day. Over half of the interned Aleuts died in Japan, largely by malnutrition. The American school teacher Etta Jones and her husband Foster Jones, the Attu radio and weather monitor, were the only Caucasians on Attu when it was overrun by 1,143 troops of Major Matsutoshi Hozumi's North Sea Detachment, comprised of the 301st Independent Infantry Battalion and the 301st Engineer Company. The Japanese held the older couple separately; each received rough treatment. Foster was executed by a single, small-caliber

Left: Imperial Navy ships in Kiska Harbor with Kiska Volcano in the background. Photo appears to have been taken from Little Kiska in the foreground. *DAITOUA*

Right: The capture of Attu. Soldiers of the 301st Infantry Battalion raise the Hinomaru—"Circle of the Sun"—Japanese flag at the village of Chichagof on Attu Island, June 6 or 7, 1942. *DAITOUA*

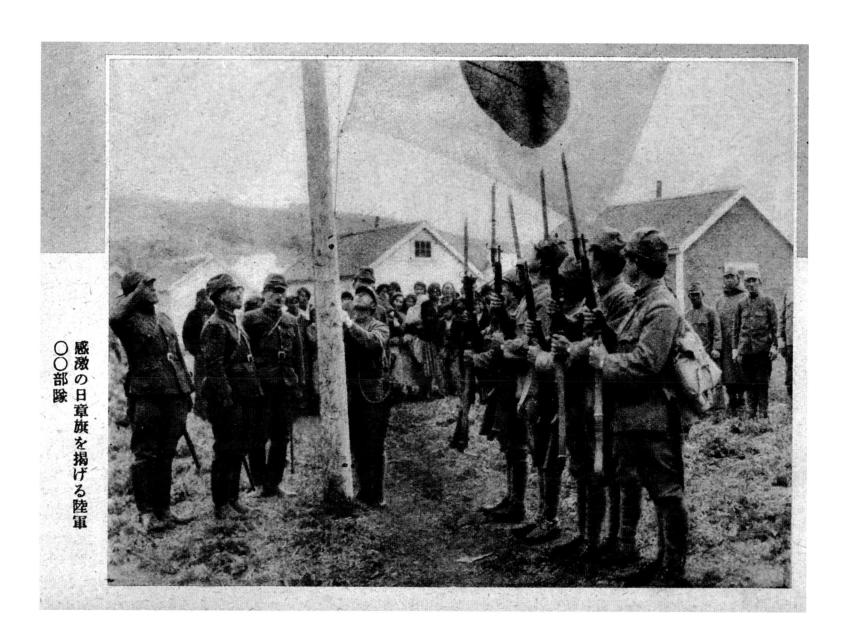

感激の日章旗を掲げる陸軍
〇〇部隊

bullet to the head during interrogation; the Aleut men buried him off a corner of the Russian Orthodox Church. Etta was knocked down, kicked repeatedly, and hit with a rifle butt. She subsequently survived thirty-nine months in successive Japanese internment sites.

On Kiska, ten men stationed at a U.S. Navy weather station were the only inhabitants when five hundred soldiers from Captain Ono Takeji's Naval Landing Force came ashore at Raynard Cove and made their way south to Kiska Harbor in the early morning hours of June 7,

1942. Machine-gun fire wracked the station's wood building as the sailors scattered. All were rounded up except for Aerographer's Mate William Charles House, who eluded the Japanese for some forty-nine days by hiding in a cave and living off grasses and shoots. On one occasion he was strafed by a plane while out foraging for food, and the island shook under heavy bombardment by American bombers as he huddled in his damp sanctuary. Cold and emaciated, he finally presented himself to an enemy gun crew for surrender.

House was put to work on Kiska as a laborer for the Japanese navy and was treated fairly well, even learning a little Japanese. On one occasion a crewman off a Japanese submarine told House how they had shelled the Oregon coast.[5] House half-heartedly asked a Japanese pilot if he would mind dropping him at Dutch Harbor with a parachute. The pilot apologized, politely saying he could not. Imperial Japanese Navy Commander Nifumi

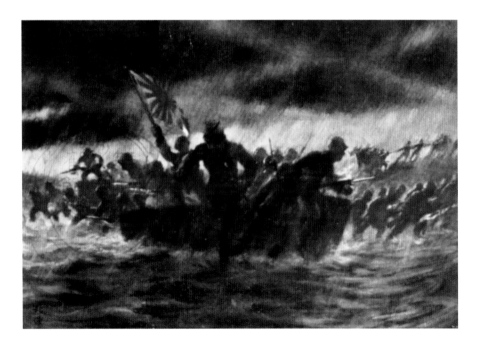

Japanese troops come ashore in the Aleutians as depicted in this painting from a Japanese propaganda postcard. This card, put out by the Imperial Navy, is one of a series of cards depicting Japanese actions in Pacific war theaters. AUTHOR'S COLLECTION, ARTIST UNKNOWN

Mukai recalled of House, "the prisoner was tall, slender, and had brown hair and blue eyes. He had a pleasant disposition and was well liked by the Japanese."

After three months as a prisoner on Kiska, William Charles House was put aboard a coal ship returning to Japan and shipped off to a succession of work camps. He survived the war and retired to California.

"I found a little ledge and a cave and rolled up my blankets and got to sleep." —William Charles House on escaping from Japanese troops

The Enemy on Kiska

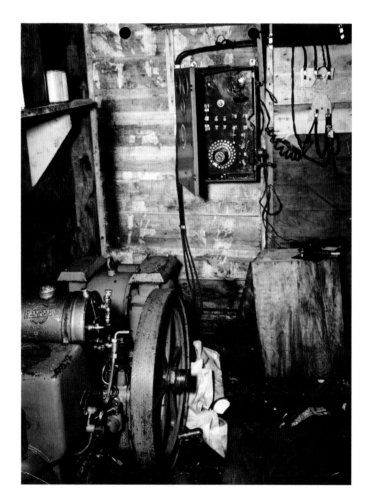

Japanese power house at the harbor 1943. PHOTO P430-78 ALASKA
STATE LIBRARY, U.S. NAVY BUREAU OF AERONAUTICS. PHOTOGRAPHER'S NUMBER 5629

Once radio dispatches from Attu and Kiska abruptly ceased, it was correctly ascertained by the American forces that the islands had fallen into enemy hands. Navy PBY flying boats configured as bombers and the Eleventh Army Air Force began a bombing campaign to disrupt any entrenchment of the Japanese on Kiska. While these initial operations had little effect, they served at least to rattle the enemy. The continued bombings of Kiska were intense and relentless. Japanese journalist Yunosuke Osawa, stationed on Kiska, wrote of the Allied bombings, "they swoop out of the clouds hitting everything indiscriminately. I express my wonder at the fierceness of the enemy bombardments."

Kiska Island was an anomaly among World War II battlefields because there was no Allied, noncombatant population on the island. That meant it could be bombed without regard for a civilian populace. Pilots from two

Royal Canadian Air Force P-40 Kittyhawk fighter squadrons later joined their American counterparts rotating into combat missions against the Japanese entrenched on Kiska. Recounting the Allied air attacks, a portion of a Japanese diary found on Kiska lamented, "twenty planes attacked and it was so severe it was strange that I survived." Another recorded "ten enemy air attacks. They made a direct hit on a gun position and killed ten men."

Kiska's fragile landscape still bears the wounds of bombardment from air and sea. It is pockmarked with bomb craters that range from forty-eight inches to sixteen feet in diameter. Oddly enough, we found that some water-flooded bomb craters support small fish—how did they get in there? Bomb craters now sustain geese, ducks, sticklebacks, and freshwater vegetation.

Beginning on August 24, 1942, the 1,800-man Imperial Army garrison on Attu Island was moved to Kiska, with the transfer completed by September 16.[6] The relocated garrison melded into the 51st Base Force under the command of Major Hozumi and established their base at Gertrude Cove, our well-protected bay on the southern half of the island. The army camp was smaller

and more austere than the navy base at Kiska Harbor, six miles to the north. We chose to camp in Gertrude Cove because we believed it had seen less public intrusion than the more established Kiska Harbor area. We also set up a spike camp at Sargeant's Cove, five linear miles northeast of Gertrude. It was outfitted with some canned food, and I brought a collapsible, single-burner butane stove. This spike camp put us closer to the harbor and allowed us more time for the professor's avian fieldwork rather than hiking. While the distances on a map did not seem great, we had to contend with very hilly, rutted terrain, climbing several hundred feet up and down, only to repeat the action. I paid the price for not getting into better shape before my arrival.

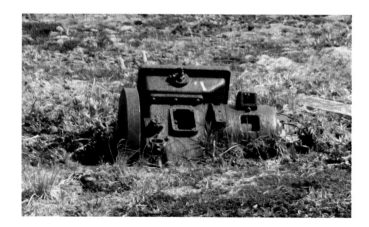

A Japanese-manufactured generator.

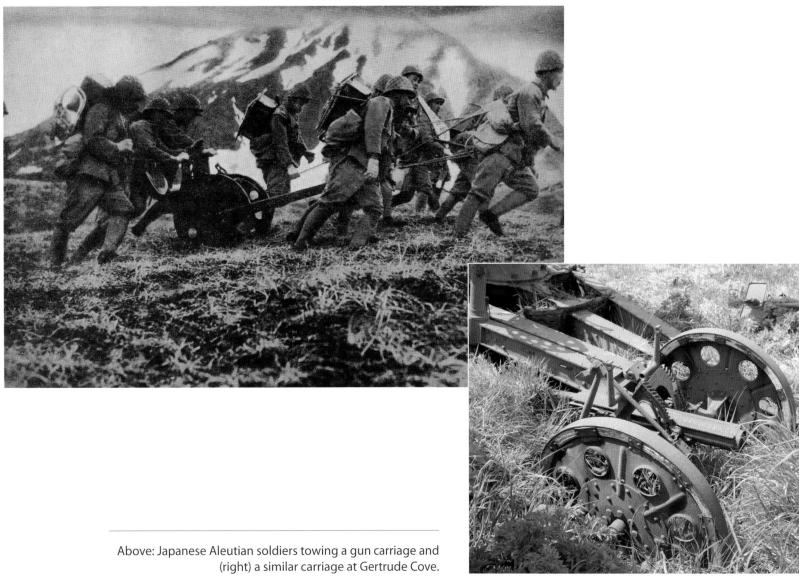

Above: Japanese Aleutian soldiers towing a gun carriage and
(right) a similar carriage at Gertrude Cove.

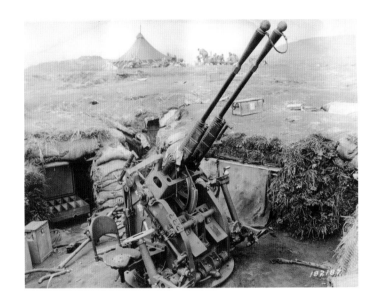

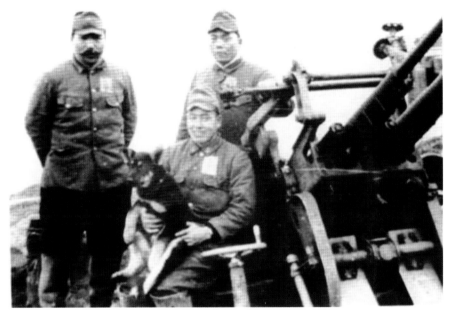

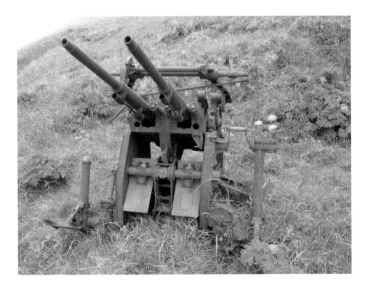

Above: Soldier holding dog is Kishichiro Miyazaki, who served on Attu before being transferred to Kiska. AUTHOR'S COLLECTION

Left top: Twin 13 mm heavy machine gun. U.S. ARMY

Left bottom: A 25 mm gun at Mercy Point, Kiska Harbor.

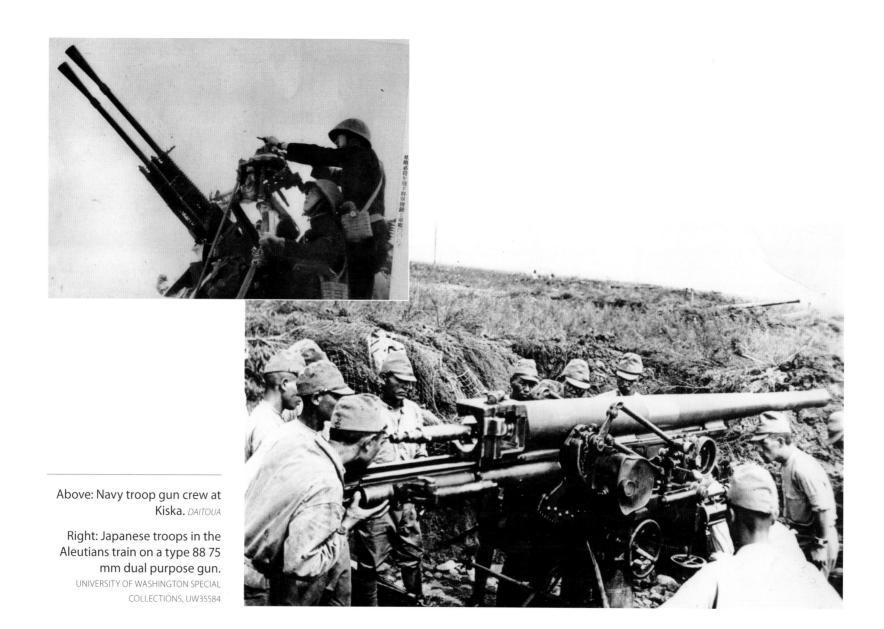

Above: Navy troop gun crew at Kiska. *DAITOUA*

Right: Japanese troops in the Aleutians train on a type 88 75 mm dual purpose gun.
UNIVERSITY OF WASHINGTON SPECIAL COLLECTIONS, UW35584

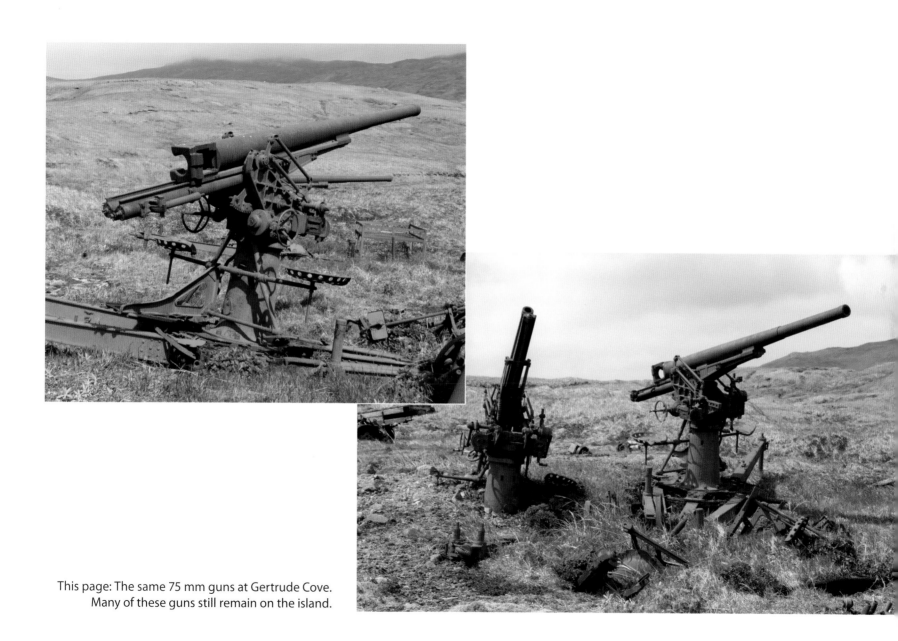

This page: The same 75 mm guns at Gertrude Cove.
Many of these guns still remain on the island.

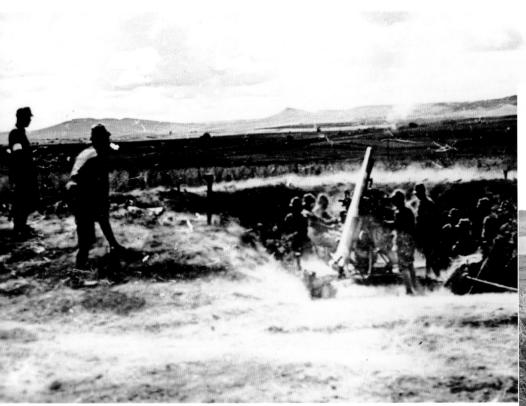

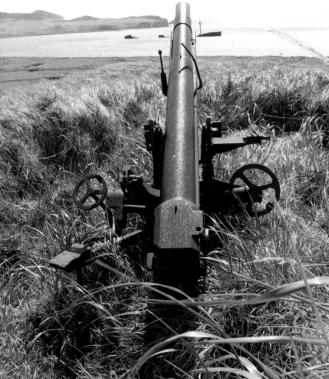

Above: Japanese antiaircraft gun in the Aleutians. UNIVERSITY OF WASHINGTON SPECIAL COLLECTIONS, UW35899

Right: A type 38 (1905) 75 mm coastal defense gun at Gertrude Cove.

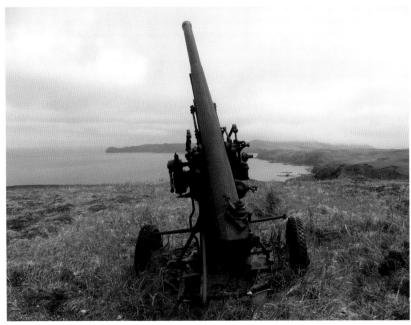

Left: Soldiers examine a Japanese 75 mm gun at Kiska Harbor, August 1943. BARNEY A. MALEY, WINNIPEG GRENADIERS

Above: A mobile incarnation of the 75 mm. Troops would have found these difficult to move in Kiska's boggy terrain.

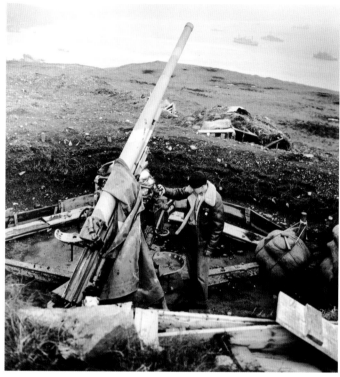

Above: Some gun pits and sentry posts were surrounded by an earthen berm. These held storage for ammunition, tools, or provisions built into the base of the revetment. PHOTO P430-74, ALASKA STATE LIBRARY, U.S. NAVY BUREAU OF AERONAUTICS, PHOTOGRAPHER'S NUMBER 5621

Left: Closeup of photo above.

Opposite: A typical pit with the gun removed.

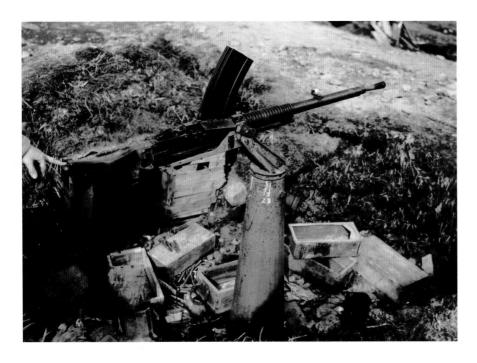

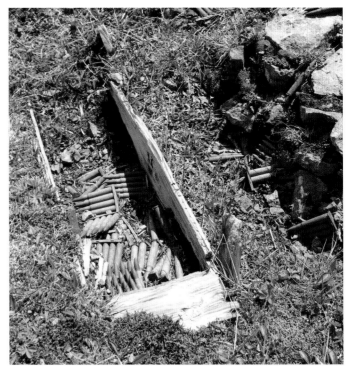

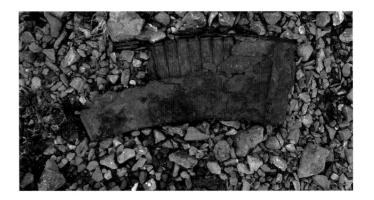

Above: Type 93 single mount 13 mm gun left on Kiska with clip and crates of ammunition, 1943. ALASKA DEFENSE COMMAND, ADVANCE INTELLIGENCE CENTER. NORTH PACIFIC COMMAND

Above right: Ammunition crates of 7.7 mm clips. Just some of the ordinance left on Kiska.

Right: Ammunition clip.

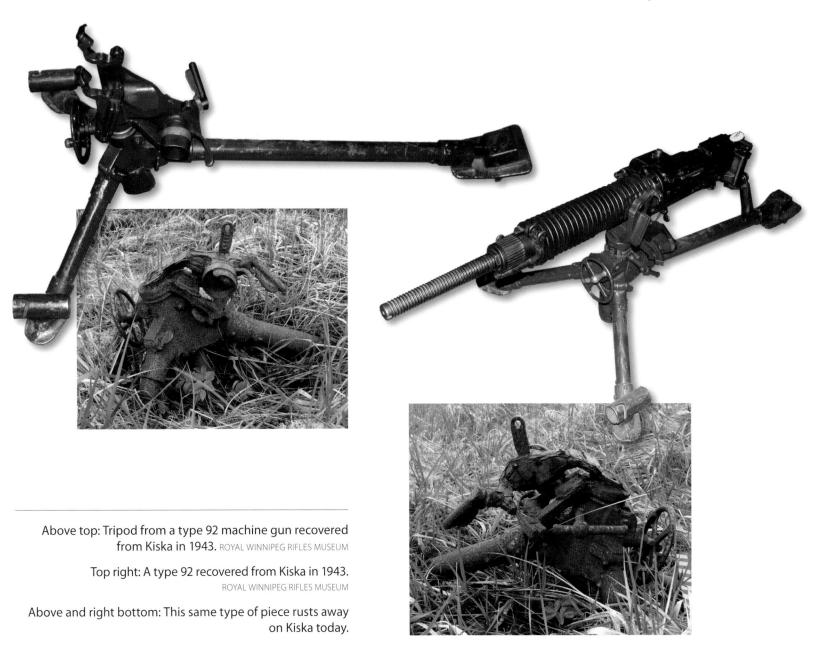

Above top: Tripod from a type 92 machine gun recovered from Kiska in 1943. ROYAL WINNIPEG RIFLES MUSEUM

Top right: A type 92 recovered from Kiska in 1943.
ROYAL WINNIPEG RIFLES MUSEUM

Above and right bottom: This same type of piece rusts away on Kiska today.

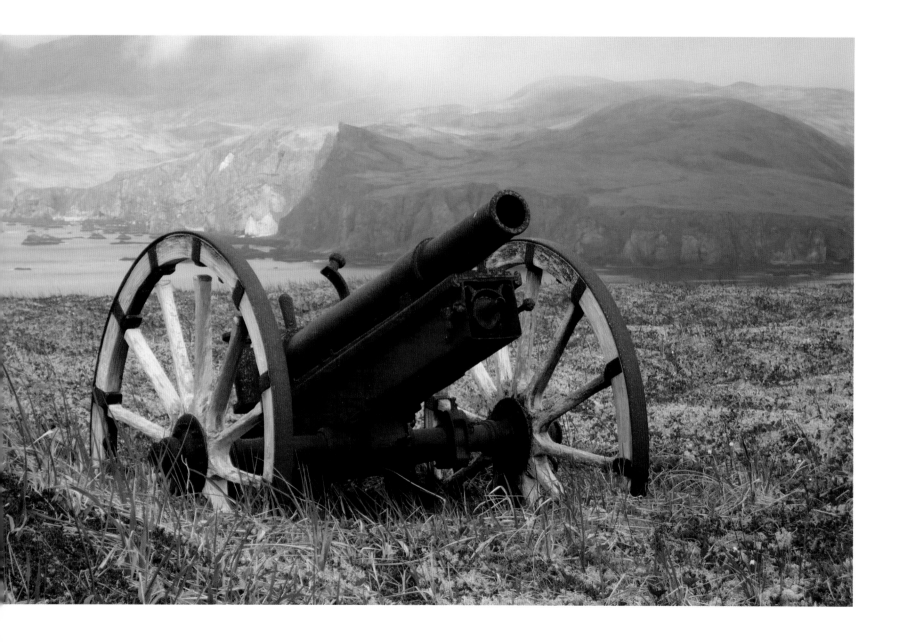

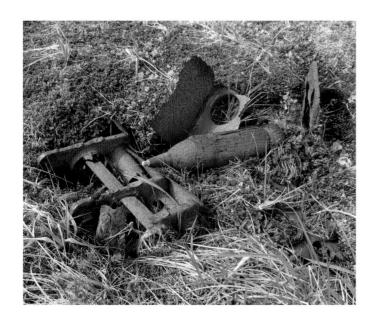

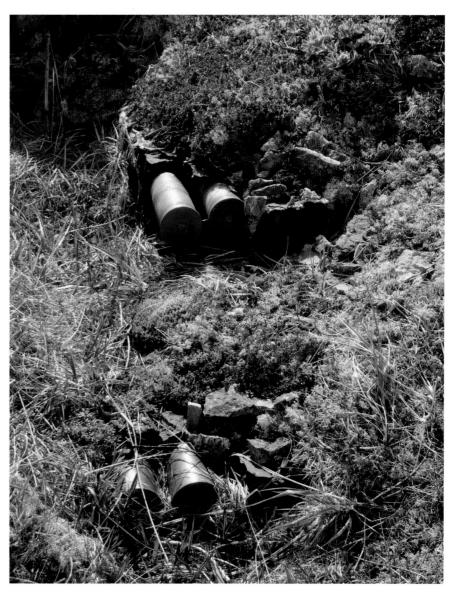

Opposite: Type 41 75 mm mountain gun. Antiquities even by the start of the Second World War, records indicated that originally there were thirty-three of the type 41 cannons on Kiska.

Above: Ammunition for type 41 cannon.

Right: Ammunition for 75 mm gun still in their boxes.

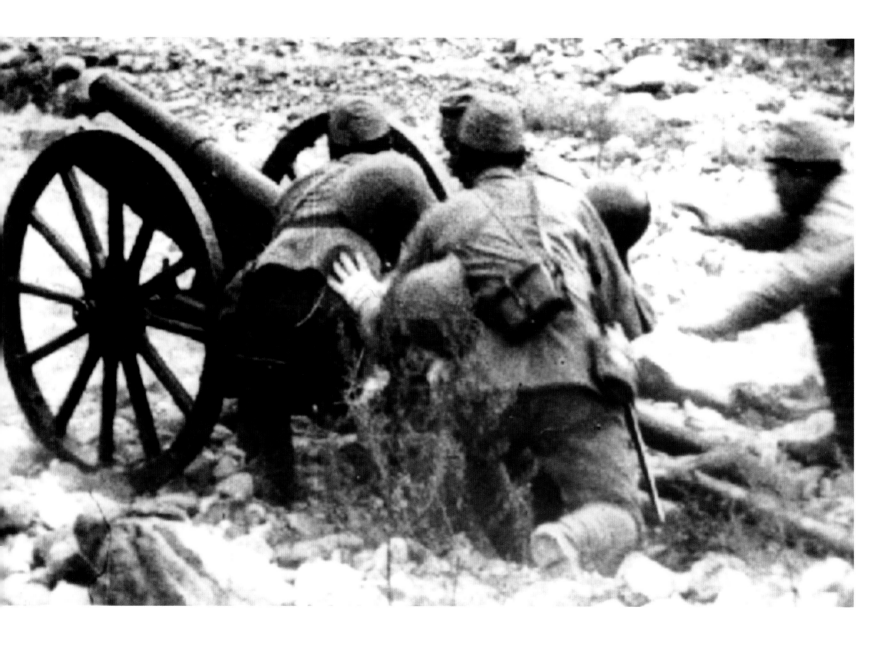

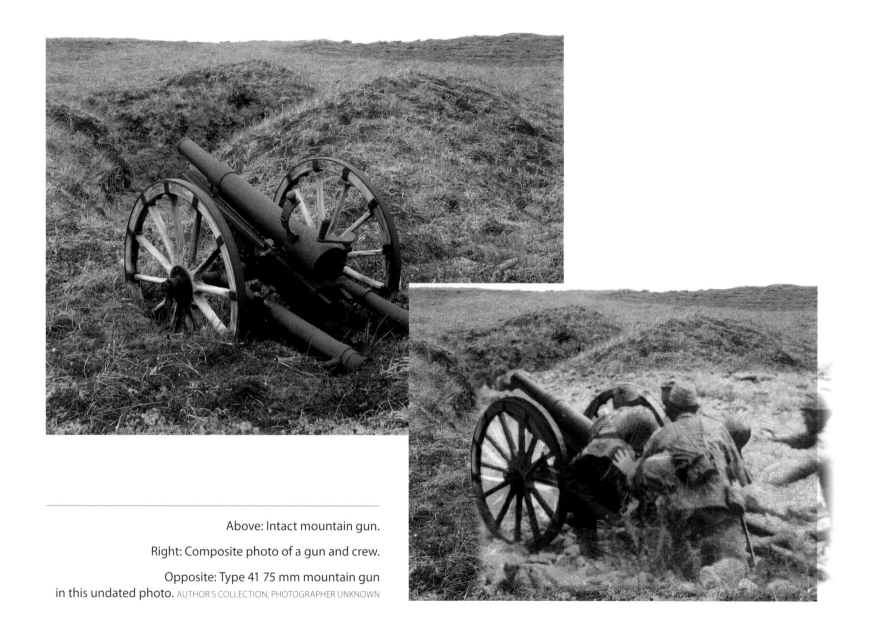

Above: Intact mountain gun.

Right: Composite photo of a gun and crew.

Opposite: Type 41 75 mm mountain gun
in this undated photo. AUTHOR'S COLLECTION, PHOTOGRAPHER UNKNOWN

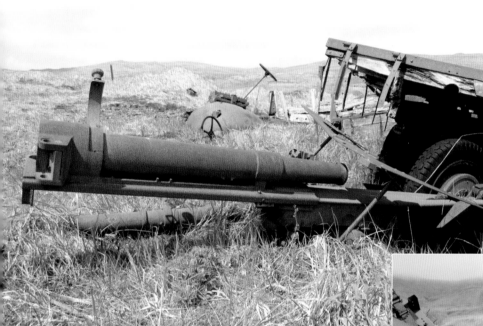

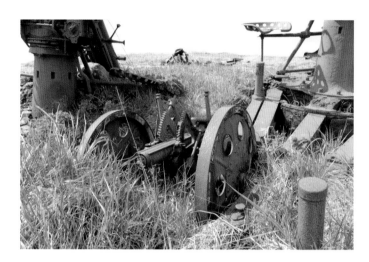

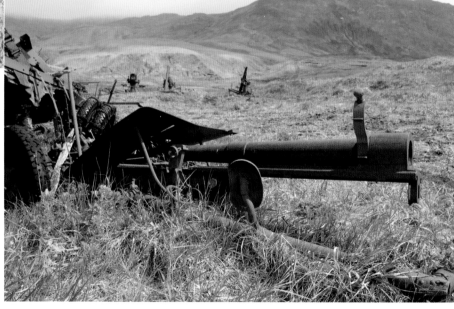

Above: Type 91 75 mm mountain gun barrel. Basically a modern version of the type 41, they had a longer barrel, modern carriage, and a fragment shield.

Upper right: Mobile gun carriage, possibly off the gun pictured to the right. All of these pieces were plowed into a dumpsite at Gertrude Cove.

Right: Note the fragmentation shield at the front of the barrel.

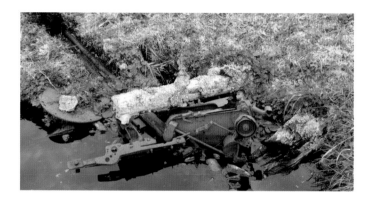

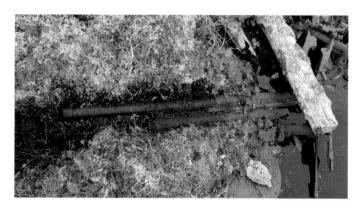

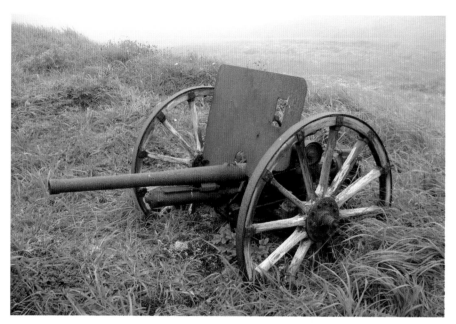

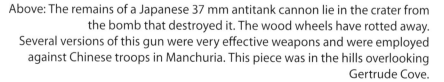

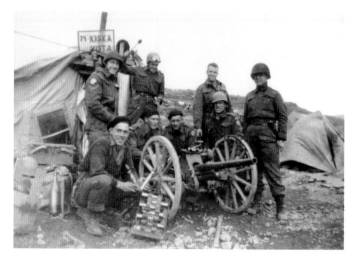

Above: The remains of a Japanese 37 mm antitank cannon lie in the crater from the bomb that destroyed it. The wood wheels have rotted away. Several versions of this gun were very effective weapons and were employed against Chinese troops in Manchuria. This piece was in the hills overlooking Gertrude Cove.

Upper right: A fully intact 37 mm field piece survives on Kiska. KENT SUNDSETH, USFWS

Lower right: Allied troops with a captured 37 mm cannon in 1943.
BARNEY A. MALEY, WINNIPEG GRENADIERS

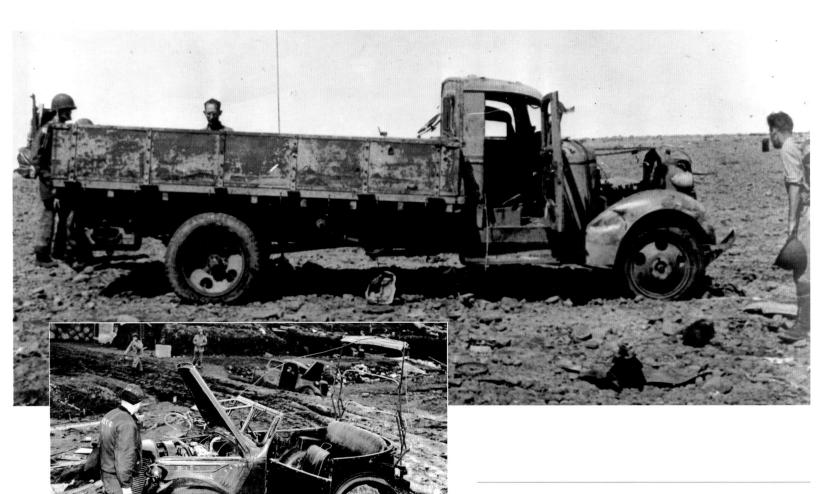

Above: The standard Japanese military truck used in the Aleutians: Type 180 built by both Nissan and Toyoda (Toyota). ALASKA DEFENSE COMMAND, ADVANCE INTELLIGENCE CENTER, NORTH PACIFIC COMMAND

Left: A Japanese motor car built by Nissan. PHOTO P430-29, ALASKA STATE LIBRARY, U.S. NAVY BUREAU OF AERONAUTICS. PHOTOGRAPHER'S NUMBER 5604

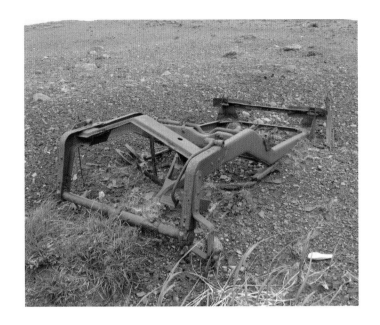

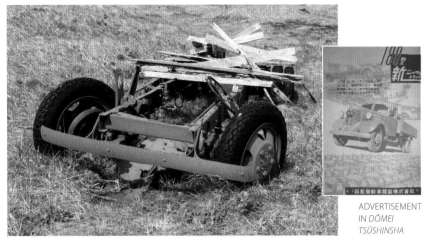

ADVERTISEMENT
IN *DŌMEI
TSŪSHINSHA*

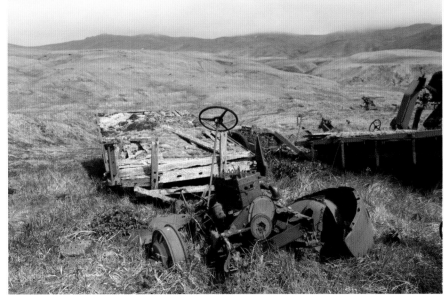

Above: Note bumpers on this frame. Possibly this overturned frame belongs to the type of Nissan motor car on the preceding page, lower left.

Upper and lower right: Type 180 trucks were built for the Imperial Army under licence to both Nissan and Toyoda (Toyota) Motor Car. Several truck bodies can be found on Kiska today. American analysis found most Japanese equipment too "light duty" for the Aleutians.

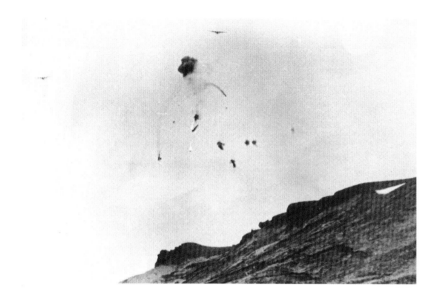

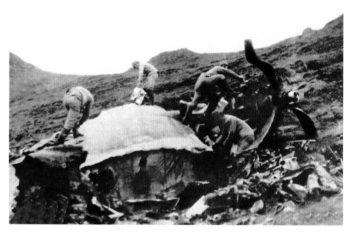

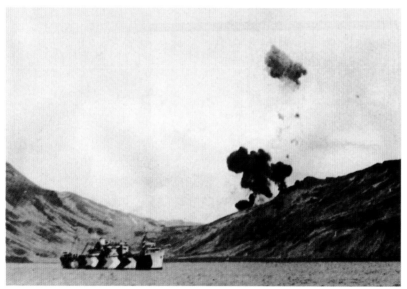

Upper left: Captain Jack F. Todd's Consolidated B-24 Liberator is destroyed midair from antiaircraft fire during this first American bombing mission against Kiska, June 11,1942. FROM A JAPANESE FILM CREW ON KISKA JUNE 1942, CINEMATOGRAPHER UNKNOWN. AUTHOR'S COLLECTION

Above: Japanese troops swarm over the right wing of Todd's B-24 Liberator. Todd and his nine-member crew were all killed in the ground-to-air battle. *DŌMEI TSŪSHINSHA*, OFFICIAL NEWS AGENCY OF THE EMPIRE OF JAPAN

Lower left: Possibly the antiaircraft fire that hit B-24D-CO bomber 41-1088 was from the *Kimikawa Maru*, seen here anchored in Kiska Harbor. Other B-24s of the five-bomber mission can be seen above the black smoke. U.S. pilots were surprised at the extent of enemy antiaircraft concentrations already on Kiska after only four days. A Japanese film crew that had accompanied the enemy invasion force caught the action over Kiska that day. FROM A JAPANESE FILM CREW ON KISKA JUNE 1942, CINEMATOGRAPHER UNKNOWN. AUTHOR'S COLLECTION

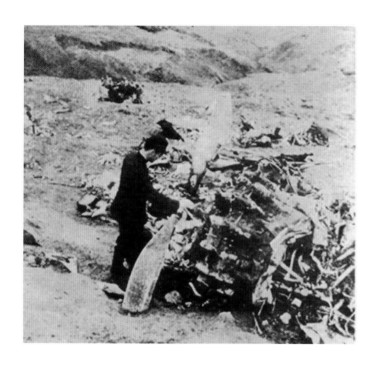

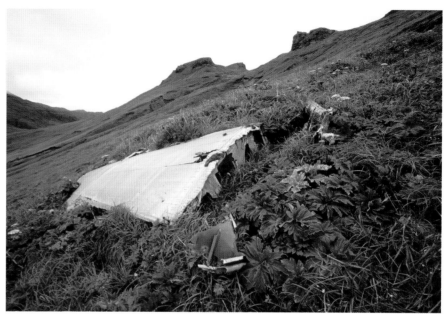

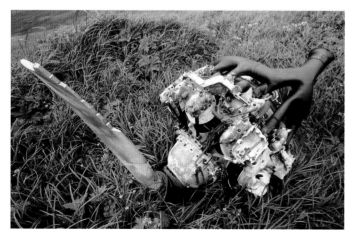

Above left: Enemy soldier inspects the Pratt & Whitney R-1830 Twin Wasp engine from Jack Todd's B-24. *DŌMEI TSŪSHINSHA*

Lower left: The same engine. IAN L. JONES

Above: The wing section today. Japanese troops scratched traditional Kanji characters into the aircraft skin. Some of this scribing is still faintly visible after sixty-nine years of exposure to wind and weather. IAN L. JONES

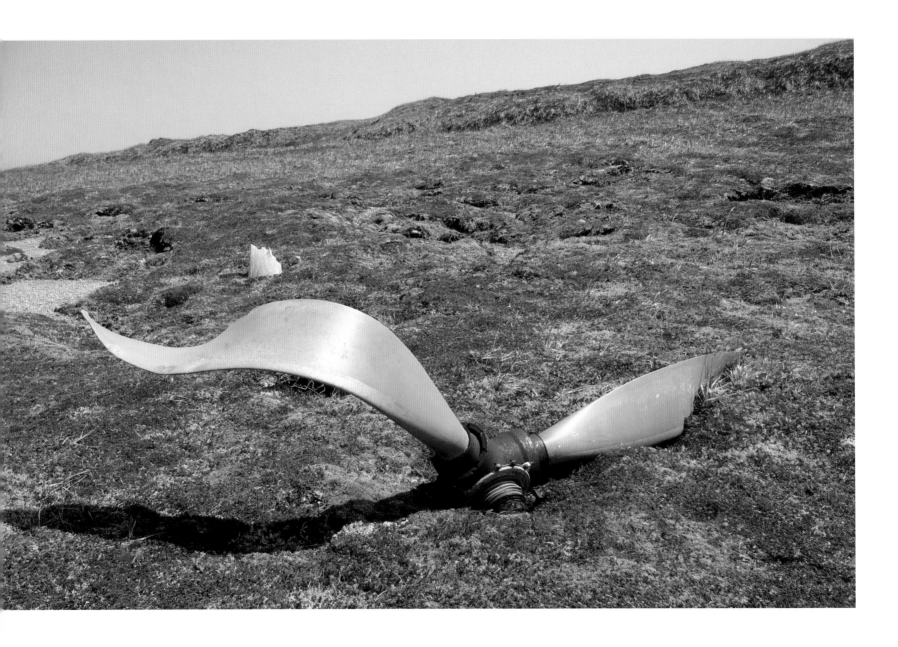

32313, the Ghost of Kiska

When the weather conditions were clear we could just see Rat Island (now named Hawadax) and Amchitka, a low, truncated island seventy-five miles to the east. Amchitka Island has a gentler topography and a roughed-out airfield. Curtiss P-40K Warhawks of the 18th Fighter Squadron made the first landing on Amchitka on February 16, 1943. The new base allowed American pilots to take advantage of breaks in the weather and step up their attacks on Kiska. However, this close proximity to Kiska also allowed Japanese antiaircraft gunners to sight aircraft groupings over Amchitka.

While we were hiking on Kiska during one of those unusually clear days, a flash of sunlight reflecting off metal caught our attention and we set out to discover the source. If not for a rare sunny day at that precise moment, we might not have come across the wreckage of a World War II fighter plane, frozen in time.

As we approached, we could see it had been a violent plane crash with a wide debris field of aircraft parts

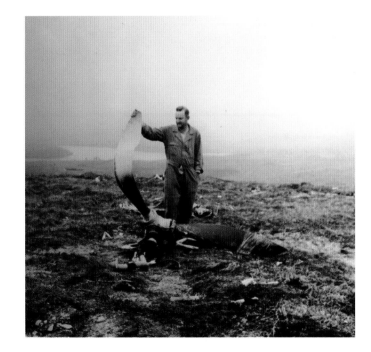

Left: Propeller from 43-2313.

Right: Propeller from 43-2313. This photo was taken by American troops who found the wreck in 1943. AUTHOR'S COLLECTION, PHOTOGRAPHER UNKNOWN

cast over a half mile. After seventy years the muskeg still bore scars where the plane smashed into the earth before breaking apart. A tail portion sported its coat of olive-drab camouflage and its number—(4)3-2313—emblazoned in bright yellow. An Allison engine, supercharger, distinctive cockpit, and twin-boom tail configuration confirmed we had found a Lockheed P-38G Lightning. The twin-engine fighter plane made its wartime debut in the Aleutians in November 1942. Flying from Adak, its extended-range fuel tanks put it within striking distance of Attu, four hundred miles west. We found neither machine guns nor a single round of ammunition present. Likely the Japanese or, later, American troops had removed the guns and all ammunition. After nearly seventy years we found the site quite intact with no evidence of salvage.

A conspicuous mound lay at the edge of the debris field. Two sections of bullet-riddled aircraft metal protruded from the mound, where we also found a Japanese spade. Under the Aleutian muskeg was a lining of large flat stones deftly arranged by a human hand, an apparent grave. Possibly one American serviceman may have been left on lonely Kiska, and Japanese soldiers had buried the pilot and placed pieces of aircraft panel on top of the grave to attract attention to the site. It was this reflection off the grave seven decades later that first caught our notice. Not sure what I was expecting to see, I poked my flashlight into the hollows of the pile, but it revealed nothing. Out of respect for whoever might be in the grave and cognizant that retreating Japanese mined all manner of routine items, we did not disturb the site. We felt the aircraft serial number should identify the plane and pilot.

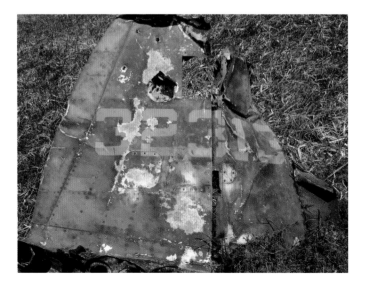

Opposite: Debris from the wreckage has changed little as evidenced in this 1943 photo and the one on page 58, taken in 2009. AUTHOR'S COLLECTION, PHOTOGRAPHER UNKNOWN

Upon returning home, we reported the wreck to JPAC, the Joint Prisoners of War, Missing in Action Accounting Command in Hawaii. They could find no record of P-38 number 43-2313. Searches with historical aircraft interests listed the plane as being everywhere but Alaska: it had deployed to North Africa and also 8,000 miles away over the Marshall Islands in the South Pacific. The serial number sequence only added to the mystery because it did not correspond with production inventories of P-38s bound for Alaska. However, it was not unusual for individual aircraft bound for foreign theatres to be pulled from an assembly run in order to make up for shortfalls elsewhere.

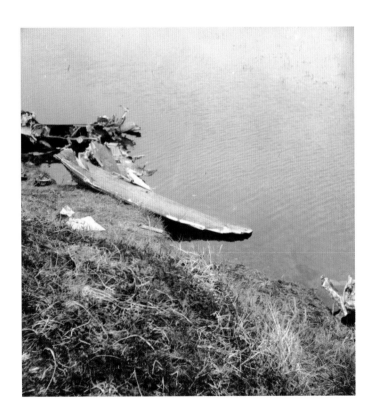

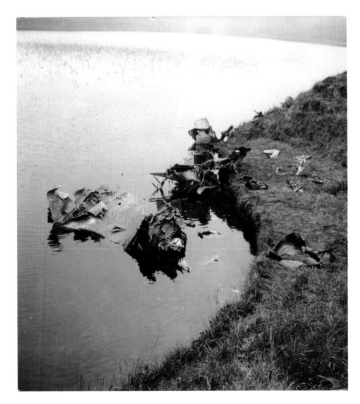

Records indicated two P-38s lost over Kiska were unaccounted for, but their 1942 loss dates did not correspond with our plane, which had the manufacture numerals 43 in its serial number. This number designated the production year of each army aircraft. Another report came to light of a P-38 damaged over Attu that disappeared attempting to return to Amchitka. The loss date was within range of our aircraft, so possibly this was our plane and it had only made it as far as Kiska before augering in.

The search for 43-2313's identity reached an impasse. The army air force only started keeping accident reports in June 1943, so possibly there was no further record of our plane. I had exhausted all of my sources, and I wasn't even sure the wreck had occurred during the war. There was a lot of Cold War activity in the Aleutians after 1945, and Kiska's airstrip was developed as an emergency runway. Our leads had gone cold. Was there still a pilot in this faraway grave? Did his family still wonder about his resting place?

The following year, I received a letter from JPAC. Andrew B. Speelhoffer, a historian with the Joint POW/MIA Accounting Command, had made it a priority to research the mystery of 43-2313. P-38G-13-LO number 43-2313 was a Lend-Lease aircraft from a batch rejected by the Royal Air Force (RAF). The RAF never thoroughly embraced the P-38 due to its lack of certain attributes such as counter-rotating propellers. Lockheed converted the initial British-bound planes into P-38Gs, which the U.S. Army Air Force deployed quite successfully in the Pacific. Our craft did in fact arrive in Alaska in late January 1943 and was written off shortly afterward in March 1943. The plane belonged to the 54th Fighter Squadron and was flown by a Captain Miles

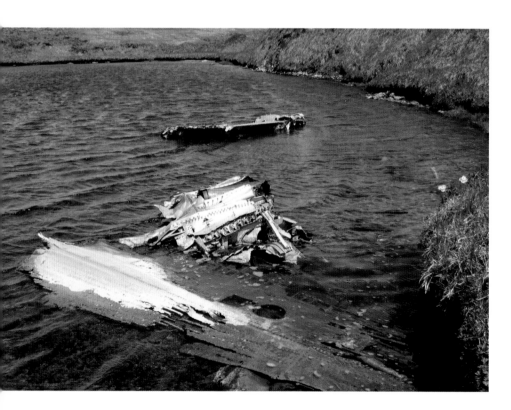

Allen Werner when it was lost in a sortie over Kiska in March 1943. Werner, of San Jose, California, was the son of Wade Werner, a prominent foreign correspondent with the Associated Press. Wade Werner spent the pre-war years of the 1930s covering Hitler's rise to power in Berlin and Stalin's infamous treason purges in Moscow. He remained in continental Europe throughout the war, and that was where he received news of the death of his eldest son over Kiska. Oddly enough, Miles Werner did not even belong to the 54th Fighter Squadron. He flew one of the gangly C-47 Skytrain cargo planes with the 54th Troop Transport Squadron, ferrying men and supplies between the American bases in the Aleutians and the Alaska mainland. Further investigation turned up an article in a 1943 Florida newspaper mentioning a correspondent covering the Aleutians war. The correspondent wrote that Werner "knows the Aleutians well and on one occasion he borrowed a plane to fly up and guide down to Umnak another pilot who was lost in the fog."

In March 1943, Werner took part in a raid on Kiska in a borrowed P-38, aircraft number 43-2313. On the ground, Japanese gunners had no shortage of antiaircraft ammunition and threw up great shards of it at the

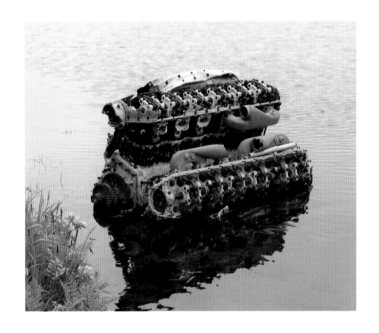

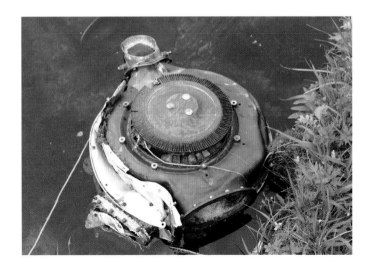

Bottom right: Allison engine; supercharger.

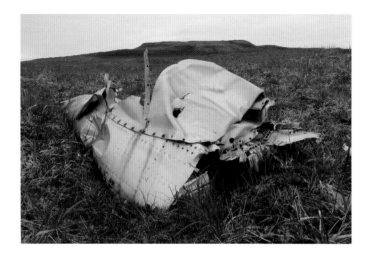

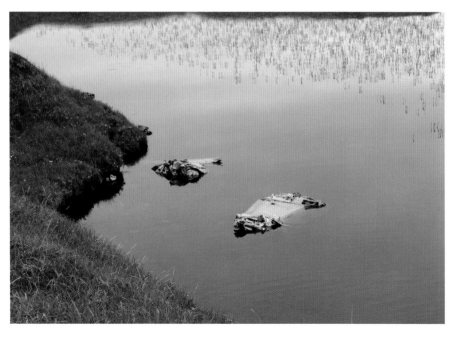

marauding planes, becoming ever more accurate right up to 15,000 feet. American aircraft crews described the flak over Kiska as "murderous" and lamented, "every plane that comes back from Kiska is shot up from the antiaircraft fire." The Japanese gunners' success was evident on Werner's P-38.

The memo on Werner dated 1943 states he was buried by the enemy, removed to Kiska's temporary Allied cemetery, and reinterred in San Bruno Cemetery, San Francisco.

At the highest point of the crash field, one of the plane's propellers, embedded upright into the muskeg, faded in and out of a ghostly fog. It seemed a fitting tribute for Captain Miles Werner.

Top left: Fuselage section.

Left: Debris.

Right: The Japanese-constructed grave of Capt. Miles Werner, 54th Troop Transport Squadron.

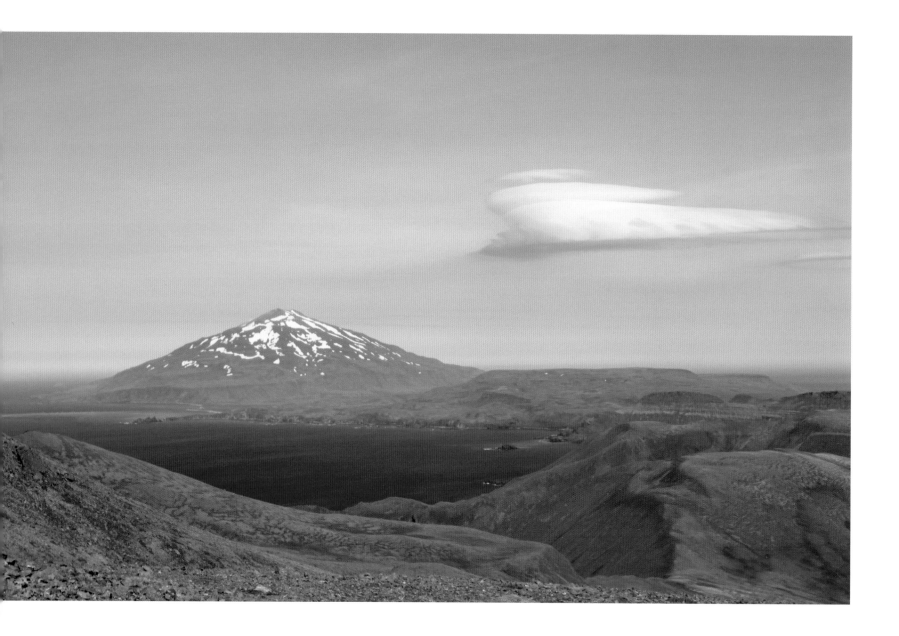

The Tedium

Other than our research expeditions between storms, we were at times pinned in our camp by heavy wind, rain, and zero visibility. We repaired gear, updated journals, and sorted photos to pass the time. Like the soldiers of seventy years past, my feet were consistently numb from inactivity and the creeping cold at ground level. I felt worn out from a continual languor of recorded episodes of *House M.D.* on the laptop, oversleeping, and gratuitous eating. Between rain squalls I took short walks along the beach, hoping something would wash up to indulge my interest for just a few moments. Appallingly, old gas containers, plastics, and tens of yards of discarded net and castaway floats befoul these remote shores. Waves crashed over the *Borneo Maru*, and its tortured steel occasionally moaned at the unremitting sea that will surely be the wreck's ultimate demise.

One day I used a lull to attend to some much-needed hygiene, as I had not shaved since Adak, three weeks past. It had been a week since I had peeled off the layers of nylon and fleece for a change of underwear, and I faced the challenge of a sponge bath and shave in the

Left: Lenticular clouds near Kiska Volcano.

Right: Sentry duty. *DŌMEI TSŪSHINSHA*, 1942, #10

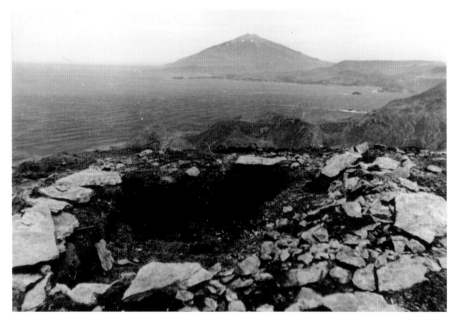

yowling cold. The gray beard of a weather-burned face glowered back from my pocket mirror. Time was measured in the growth of facial hair, and the five razor blades I'd brought proved a gross overestimation of my needs. My laundry wash water was coal black, but I felt rejuvenated by the act of bathing and the feeling of being clean-shaven with clean clothes.

Our washroom "facility" was fifty yards down the beach—essentially a private place amongst the rocks in which to squat at the water's edge. In this position the North Pacific found fit to smack my bare posterior with a frigid and unexpected wave. My short boots filled with water and the sudden, glacial shock caused me to flounder backward into the surf. Additional surges of excruciating cold added insult to injury as I rolled in the waves like a beached, hyperventilating sea lion, my pants and underwear askew. The sea not only has a soul, it has a sense of humor.

Above left: Kiska's rugged beauty.

Below left: The Kiska volcano in 1943. Note the Japanese dugout in the foreground. AUTHOR'S COLLECTION

Buildings and Bunkers: Life on Kiska

Traditionally, imperial forces were highly competitive with a strong distrust between the navy and army, but this division was not overly apparent on Kiska. A 1,200-foot mountain ridge separated the navy at Kiska Harbor and the army at Gertrude Cove. A footpath and later a road and telephone pole grid connected the navy and the army bases, and sports competitions between the forces were encouraged. On the larger scale, however, the estrangement between the Imperial Navy and Imperial Army was entrenched up to the top admirals and generals at the Imperial war office. Each command conducted major endeavors separately, working on similar projects without any exchange of information or consolidation of resources to avoid duplication. This was one of many contributing factors in the failure of Japan's military leaders in strategic planning, a process also clouded by an extreme over-estimation of what could realistically be achieved. At war's end both the army and navy competed to build an atomic bomb, racing each other on separate projects that ultimately failed.[7]

The navy troops at Kiska Harbor fared better than their army counterparts at Gertrude Cove. The navy had large power plants that supplied an abundance of electricity, bath houses, hot water boilers, recreation facilities, a piped freshwater and fire control system, and regular supply vessels. Much of the army garrison lived in tents and had only oil lanterns, two small generators for the radio and repair shop, and only sporadic visits from supply ships.

ADVANCE INTELLIGENCE CENTER, NORTH PACIFIC COMMAND

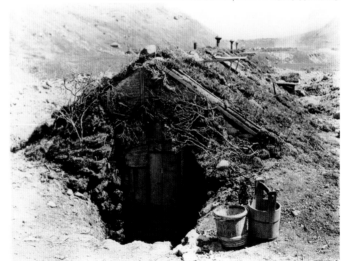

By February 1943 the Japanese had constructed 266 wood buildings, mainly at the navy and army bases. The Americans gave each building a number to make it simpler to distinguish targets. Few buildings were left untouched by the time the allies reclaimed Kiska. Allied troops greatly altered some areas of the Japanese camps, for example bulldozing Japanese structures and their berms to accommodate the large American field tents with wood floors and coal stoves—coal supplied courtesy of the Japanese. We came across canvas tent remnants, guy wires, tent spikes, and metal caps that held stove pipe. Enemy buildings were dismantled and their wood planks put into a central lumberyard for reuse.

Of the original buildings, only the earthwork berms that surrounded each building remain. These berms protected the squat wood buildings from wind and acted as a blast shield from bombs. The Japanese building foundations were narrow and dug out by pick and shovel. The Japanese also dug food storage pits outside each barrack. There is a significant drop in temperature at ground level so the pits worked very well for storing perishable foods. This system also served us well seventy years later.

Some barracks had attached tunnels, about fifteen feet long and built into an adjoining hill or mound. These

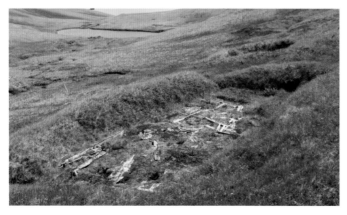

Upper left: Barracks on Kiska were built into the earth or had a compacted, earthen berm to protect from wind and more importantly, blasts from bombs. Note the camouflage coverings on the roofs of the buildings. ALASKA DEFENSE COMMAND, ADVANCE INTELLIGENCE CENTER, NORTH PACIFIC COMMAND

Lower left: The remains of one such barrack today.

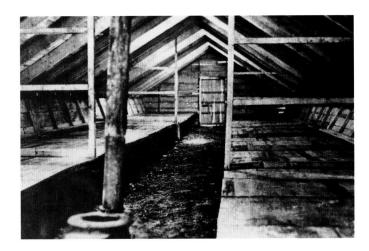

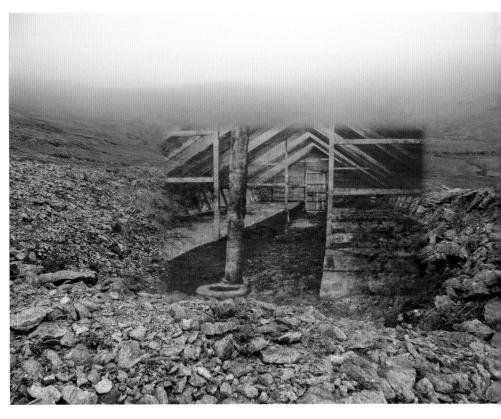

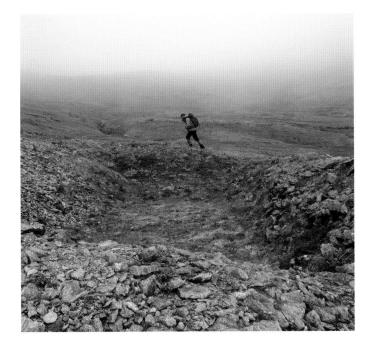

Above left: Interior of one barrack. While the navy troops at the harbor were housed in barracks with stoves, many of the army troops were billeted in tents—not a welcome situation in the Aleutian winter. UNIVERSITY OF WASHINGTON SPECIAL COLLECTIONS, UW35897

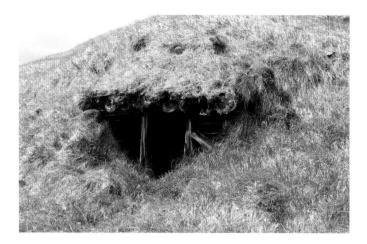

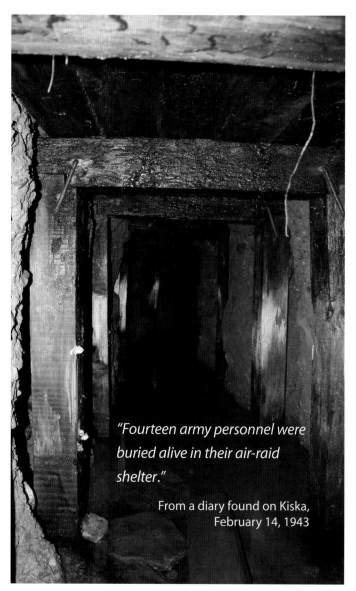

spaces had steps carved out of the earth and were used for storage and as air raid shelters. When bombing began, the soldiers took refuge in these shelters.

Kaoru (Karl) Kasukabe, a Japanese intelligence officer who grew up in the United States, recalled a direct bomb hit on his barrack that buried him alive. Kasukabe drifted in and out of consciousness over several hours, believing he would die. Soldiers frantically dug the injured Kasukabe free, but he lost all of his personal effects. He was later evacuated with other injured personnel by submarine.

We found several of these tunnels partially collapsed but did not venture far inside. One was always mindful that the nearest help was a thousand miles away on Kodiak.

"Fourteen army personnel were buried alive in their air-raid shelter."

From a diary found on Kiska,
February 14, 1943

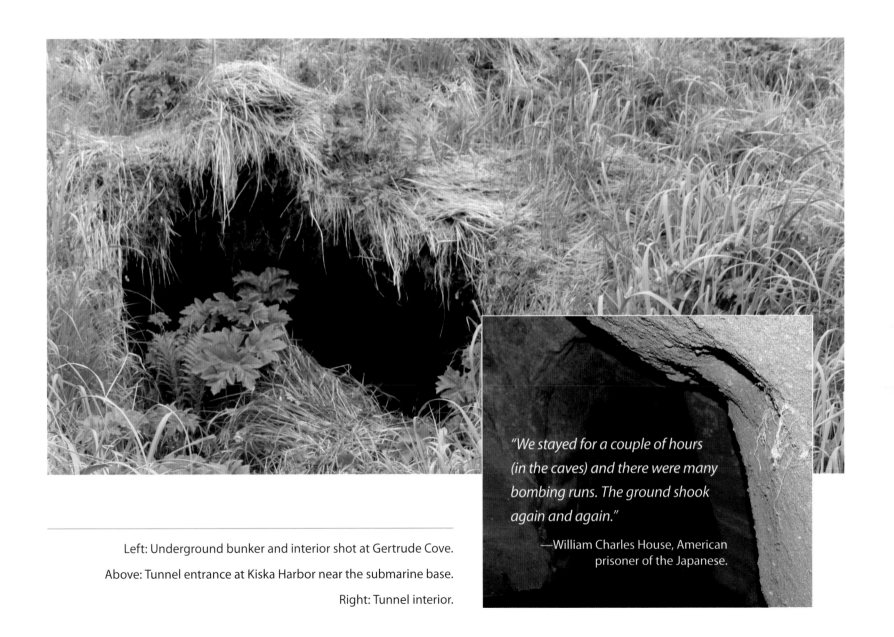

"We stayed for a couple of hours (in the caves) and there were many bombing runs. The ground shook again and again."

—William Charles House, American prisoner of the Japanese.

Left: Underground bunker and interior shot at Gertrude Cove.

Above: Tunnel entrance at Kiska Harbor near the submarine base.

Right: Tunnel interior.

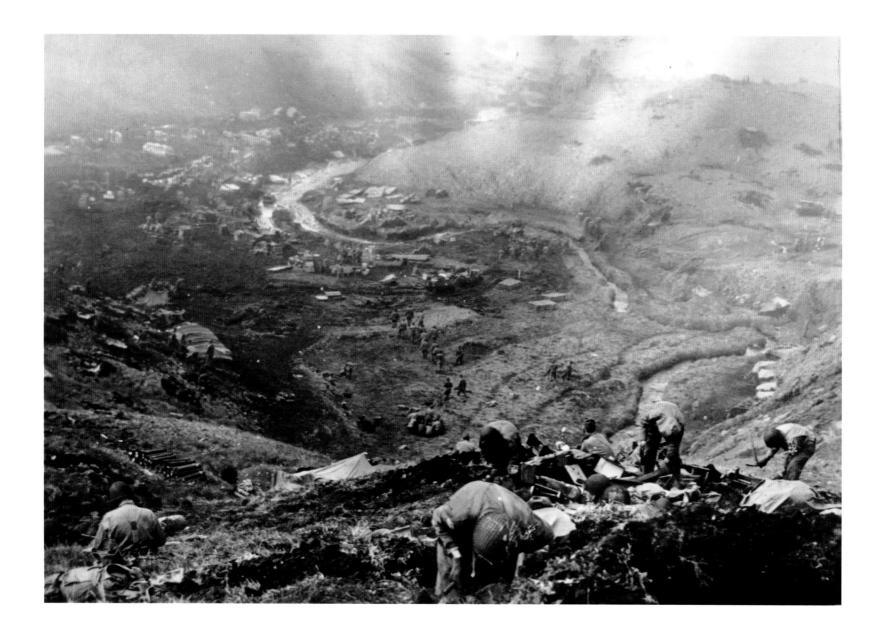

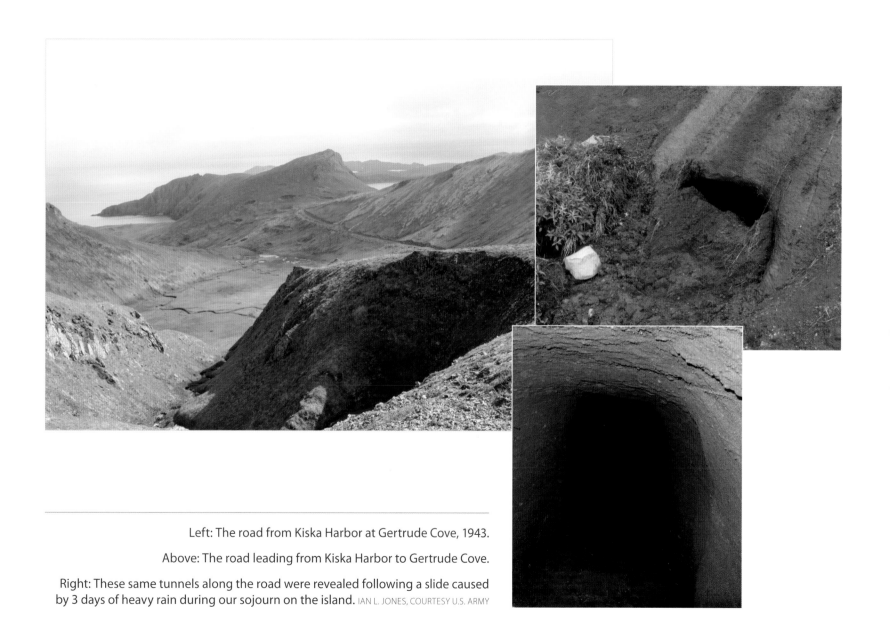

Left: The road from Kiska Harbor at Gertrude Cove, 1943.

Above: The road leading from Kiska Harbor to Gertrude Cove.

Right: These same tunnels along the road were revealed following a slide caused by 3 days of heavy rain during our sojourn on the island. IAN L. JONES, COURTESY U.S. ARMY

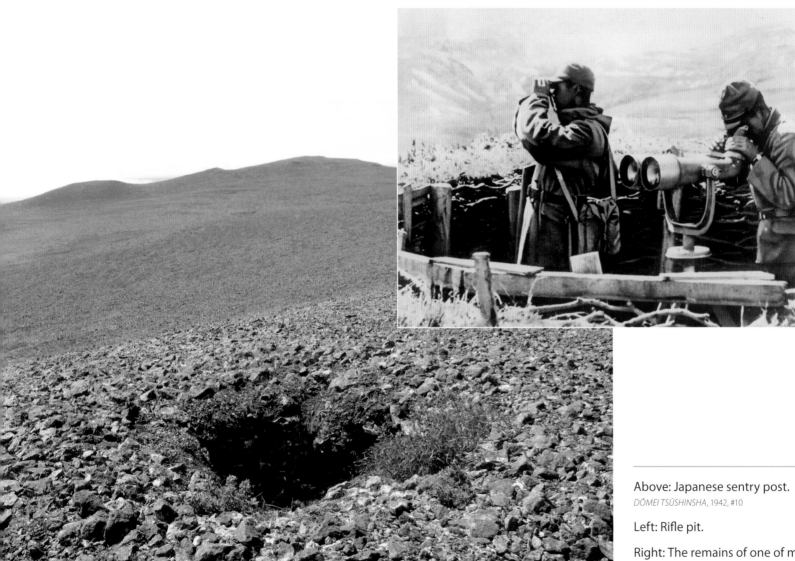

Above: Japanese sentry post.
DŌMEI TSŪSHINSHA, 1942, #10

Left: Rifle pit.

Right: The remains of one of many such installations today.

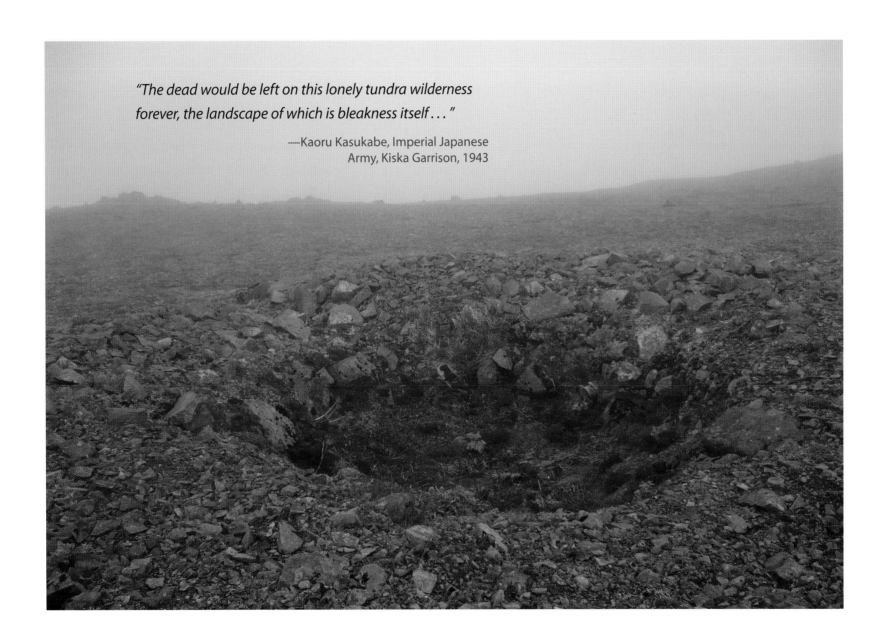

"The dead would be left on this lonely tundra wilderness forever, the landscape of which is bleakness itself . . . "

—Kaoru Kasukabe, Imperial Japanese
Army, Kiska Garrison, 1943

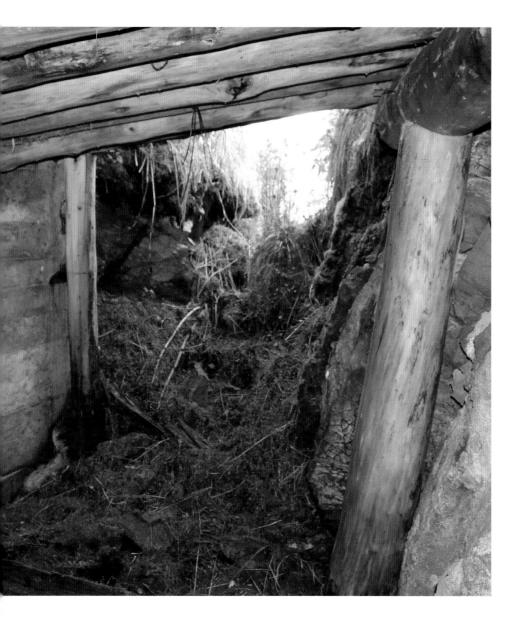

Above: Many dugouts are still to be found at potential invasion beaches. Had the Japanese not abandoned Kiska, the allies would have found a well-entrenched enemy.

Left: The Japanese were well established on Kiska. This machine gun bunker overlooks the beach at Gertrude Cove and is augmented with rifle pits dug into the cliff wall that overlooks the beach.

Bastion Kiska

We set up our spike camp at Sargeant's Cove, about five miles northwest of Gertrude Cove. This allowed us to extend our range and spend more time at the harbor. Otherwise, it was an all-day trek to the harbor and back, leaving little time for exploration or biology work. Our treks took us through the lowland marsh of the coves, where we followed one of the roads or footpaths built by the Japanese construction battalions far up into the mountains. In the slow-healing tundra, these trails still show the damage inflicted on the Aleutian substrate by thousands of hobnail boots. Five hundred Japanese civilian workers were sent to Kiska to carry out the mundane construction and road building, a task made all the more difficult under bombardment from Allied war planes and U.S. Navy ships. Some five hundred Japanese personnel were killed on Kiska, but we found no sign of graves. According to prisoner of war Charles House, gruesome ritual surrounded the Japanese

DŌMEI TSŪSHINSHA

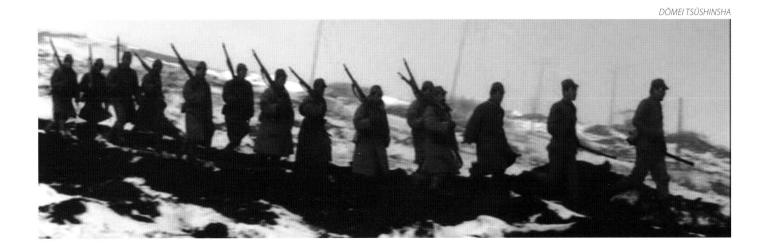

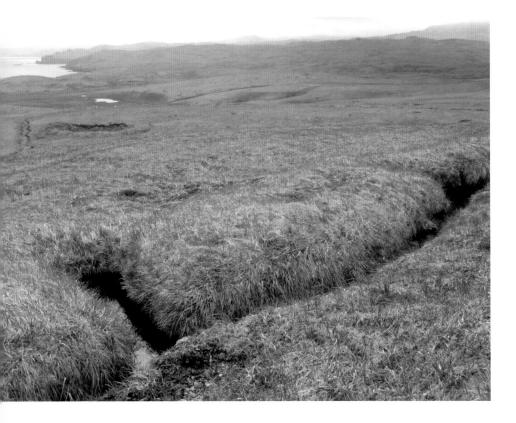

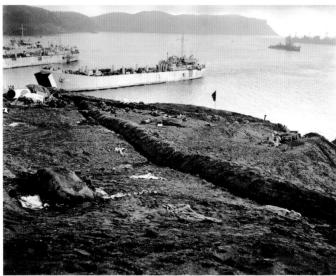

Above: Enemy trenches with rifle positions line either side of the valleys leading up from the beach. IAN L. JONES

Above right: Invading allies found Japanese slit trenches ringed nearly all potential invasion beaches. Some incorporated old Aleut sod houses—*barabara*—into their defense network, part of which can be seen in the foreground in the picture at the right. North Head is in the background. PHOTO P430-28 ALASKA STATE LIBRARY, U.S. NAVY BUREAU OF AERONAUTICS, PHOTOGRAPHER'S NUMBER 5605

dead on Kiska. The corpses were smashed to completely shatter the bones, and the remains were then stuffed into surplus ammunition boxes of about 3 x 1 x 1 feet and sent to Japan to be cremated, with the ashes sent to relatives for burial. The funerary rite was so ingrained in Japanese culture that much-needed resources on Kiska were expended to ensure remains were returned to the family.[8]

Kiska Harbor was the bastion of Japan's possessions in the Aleutians and thus reinforced with significant installations supporting approximately 7,600 personnel: a base for submarines complete with marine railway and

workshops, a bakery, a battery-making facility, a ve-hicle transportation depot, a seaplane base, a hospital, anchorage for large ships, permanent wood buildings, sheltered workshops, and a network of underground tunnels and infirmaries. The base was protected by four 120 mm dual-purpose guns at North Head; four 75 mm antiaircraft batteries at South Head; four 25 mm antiair-craft batteries behind the main camp; three 6 inch navy guns at Little Kiska Island; five 13 mm antiaircraft guns and four 20 mm machine guns dispersed at Little Kiska, North Head, the submarine base, and at the radar sta-tions; generator-powered searchlights; three light tanks; and three sets of German-manufactured radar—all be-hind multiple rows of barbed wire. A classified report by the Military Intelligence Division on the enemy's beach defenses notes, "accessible beaches were heavily mined, and tank traps blocked the overland exits from them. Barbed wire was strung between breaks in the bluffs, and from the high ground at their extremities the beaches were covered by well camouflaged and strongly con-structed machine-gun positions and rifle pits."

Kiska's beaches are lush with the long-bladed rye grass (*Elymus mollis*), which the original Unangan inhabit-ants used for clothing, baskets, bed lining, and fuel. Rye grass grows five feet tall and is thick and abundant along stretches that the Japanese viewed as potential routes for amphibious landings. Above these potential invasion

beaches, we found the valleys lined on both sides with row upon row of trenches, mortar stations, and rifle pits, all well concealed in the spiky rye grass. The ground is naturally waterlogged and rutted so I had to mind ev-ery step, making walking cumbersome and tiring. Rows of barbed wire traversed these valleys to further slow an infantry advance. An invading army would have

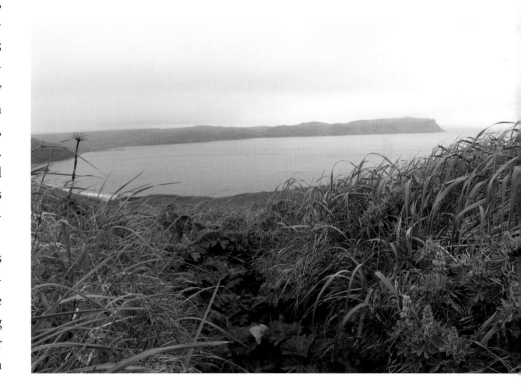

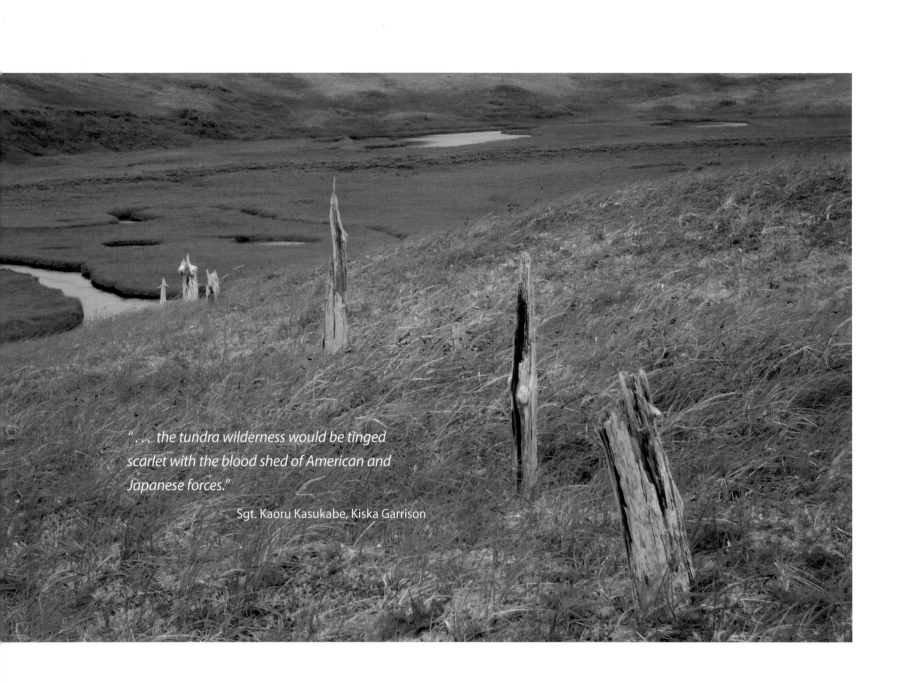

"... *the tundra wilderness would be tinged*
scarlet with the blood shed of American and
Japanese forces."

Sgt. Kaoru Kasukabe, Kiska Garrison

come under intense crossfire had they chosen to land and advance here. This setup was typical of almost all beaches and valleys on the east side of Kiska. Antitank traps at neighboring Mutt and Jeff Coves blended well into the flora, so defenders could rain down withering fire from their hidden posts onto any Allied landings. To defend against air attacks, the Japanese constructed gun emplacements that stationed 75 mm guns and 13 mm twin-barreled antiaircraft guns; some of these are still prominent. Other dugouts were watch-keeping outposts stationed well up into the mountains with the occasional underground bunker, rifle or machine gun position, and tunnel. The Japanese also dug mummy pits, single-person hollows where a soldier could lay in wait to ambush advancing enemy troops. We followed these trenches and pits far up into the hills of Lawson Ridge overlooking Conquer Point and Witchcraft Point, where the Allies came ashore.

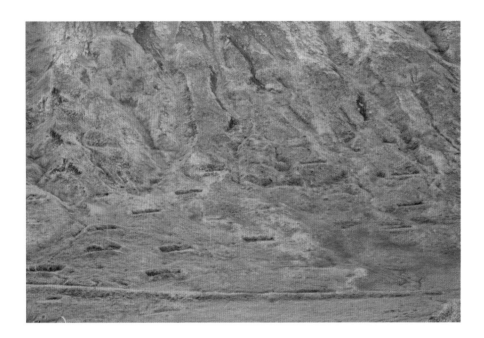

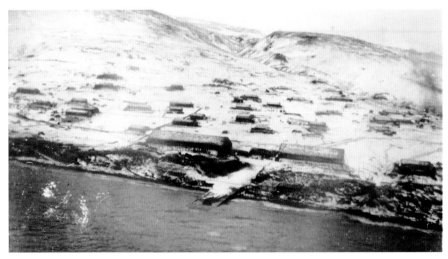

Left: Row after row of barbed wire made to slow down any Allied advance.

Top right: Building revetments at Trout Lagoon.

Right: The seaplane base at the north end of the harbor.

UAF-1970-11-75, ALASKA AND POLAR REGIONS COLLECTIONS, UNIVERSITY OF ALASKA FAIRBANKS. SAN FRANCISCO *CALL-BULLETIN* COLLECTION, ALEUTIAN ISLANDS PHOTOGRAPHS, 1942–1948

Our view of these landing beaches was short lived. Within minutes the wind turned merciless, driving cold with a hurricane force that caused water to stream from my eyes. It pushed me, unwilling, toward the looming precipice. The description of one hundred mile-per-hour fog is an apt one, and I fell to the ground for relief from the relentless williwaw. There was no longer any point in trying to sight birds, and I swore aloud at the damned island. It made me wonder how the Aleut could live in such a place.

We screamed above the wind's jet blast, making plans to get off the ridge. As we descended, the desolation of the stony slope gave way to scrappy vegetation. Once we were under the fog, the wind stopped shrieking. In a few hundred yards we went from the frenzy of the williwaw to absolute serenity, coming out on a large, natural water garden replete with waterborne flowers and trickling waterfalls. In the evening my ears were still ringing from the wind.

On a rare clear day we ascended the second highest peak on Kiska, an 1,840-foot mountain on the island's western side. Here the immense Pacific is an infinite blue canvas contrasting Kiska's stark panorama. The volcanos of Kiska, Little Sitkin, Cereberus, and Gareloi line up visibly in this boundless North Pacific realm.

The higher we climbed, the more basic were the dugouts and one-man rifle pits. They were laboriously dug out of the gravel and lined with the abundant flat ledge stone that layers the mountaintop. These defensive fall-back positions were burrowed to stall an enemy advance and were a common strategy of the Japanese throughout the Pacific campaigns. Kiska's windy crag would be

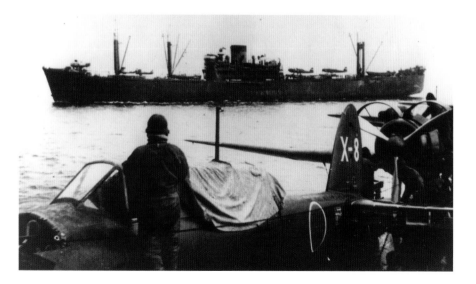

Left: Seaplane carriers deliver fighter planes to Kiska.

Right: Float planes take a pounding from the surf. In the background can be seen Mercy Point in Kiska Harbor.

a desolate and awful place to die. We constructed a cairn of rocks with our names, dates, and other details left in a plastic water bottle for the possible rare visitor.

Despite these harsh conditions, life for the Japanese soldier on Kiska was in many ways preferable to those of his counterparts on the South Pacific atolls. The disease and pestilence rife in the tropics was nonexistent in the cold North Pacific, except for maladies brought by the soldiers themselves.

The Japanese soldiers did not want for food on Kiska. Army intelligence officer Lieutenant Irving P. Payne conducted an inventory of items left on Kiska following the Japanese abandonment of the island. Caches of rice, noodles, dried fish, tinned clams, oysters, beer, sake, dried seaweed, bean paste, bottled fruit, and vegetables were found in generous quantities.

Supplementing military rations, personal accounts describe salmon as plentiful and fishing a favorite pastime of the troops. Trout in the small lakes and pink salmon massing at the creek mouth near camp in mid-August would have made a worthy distraction from the war as well as a source of fresh food. Cow parsnip (*Heracleum Lanatum*) is naturally abundant in the Aleutians, and its immature celery-like stalk is edible before the plant flowers, although I found it quite bland. Soldiers also consumed the shoots of fiddlehead ferns. Some Japanese troops even planted small plots of radishes and beans to

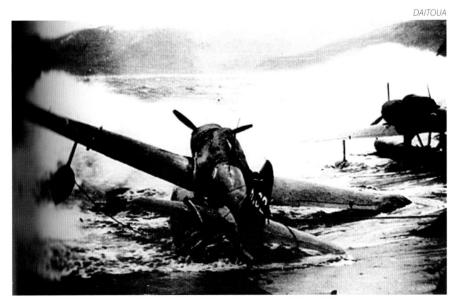

DAITOUA

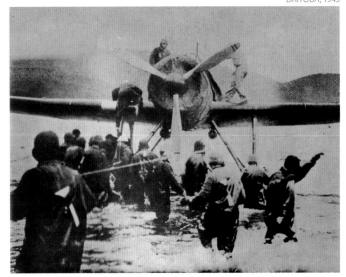

DAITOUA, 1943

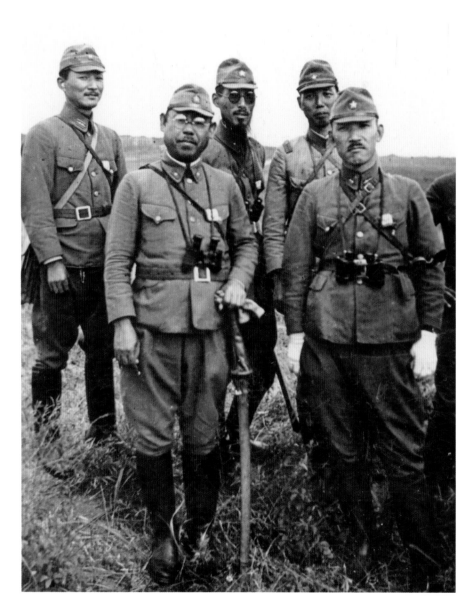

DŌMEI TSŪSHINSHA, 1942, NO. 10

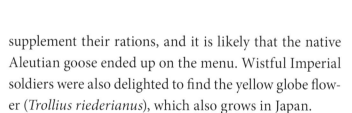

supplement their rations, and it is likely that the native Aleutian goose ended up on the menu. Wistful Imperial soldiers were also delighted to find the yellow globe flower (*Trollius riederianus*), which also grows in Japan.

Left: Imperial Army officers on Kiska. UNIVERSITY OF WASHINGTON SPECIAL COLLECTIONS, UW 27006Z

Above: The yellow globe flower is abundant in the Gertrude Cove camp area.

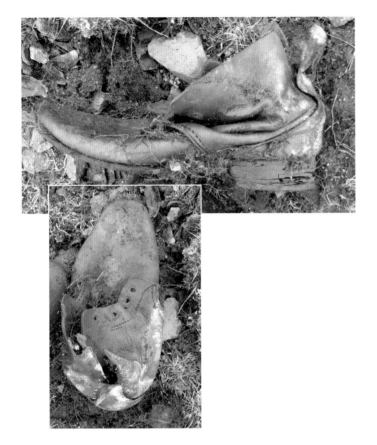

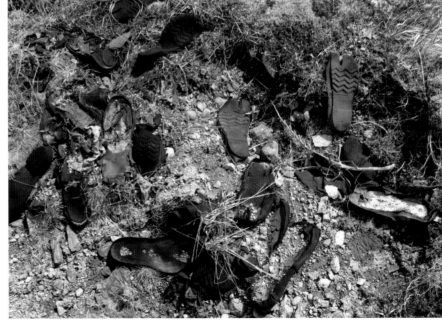

Above: The trademark hobnailed boot of the Japanese soldier. IAN L. JONES

Upper right: *Jikatabi*, traditional two-toed footwear.
SOLDIER'S GUIDE TO THE JAPANESE ARMY; MILITARY INTELLIGENCE SERVICE

Lower right: One dumpsite contains various types of Japanese footwear. IAN L. JONES

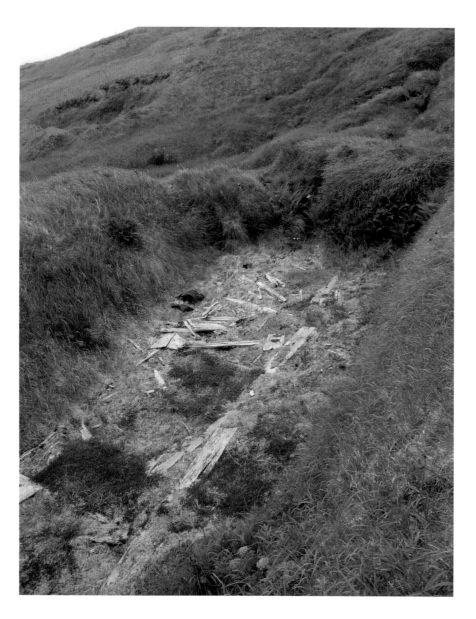

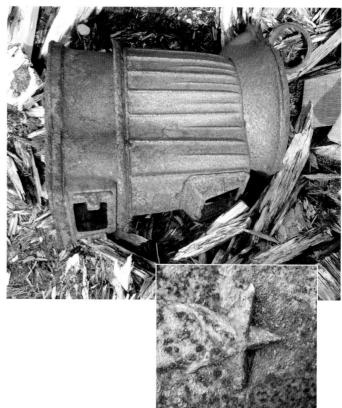

Left: Barrack remains.

Above top: Typical coal stove.

Above lower: Star of the Imperial Army on a coal stove.

Opposite: The islands afforded no comfort. Valuable space on freighters was taken up to ship coal and even firewood to the Aleutians.

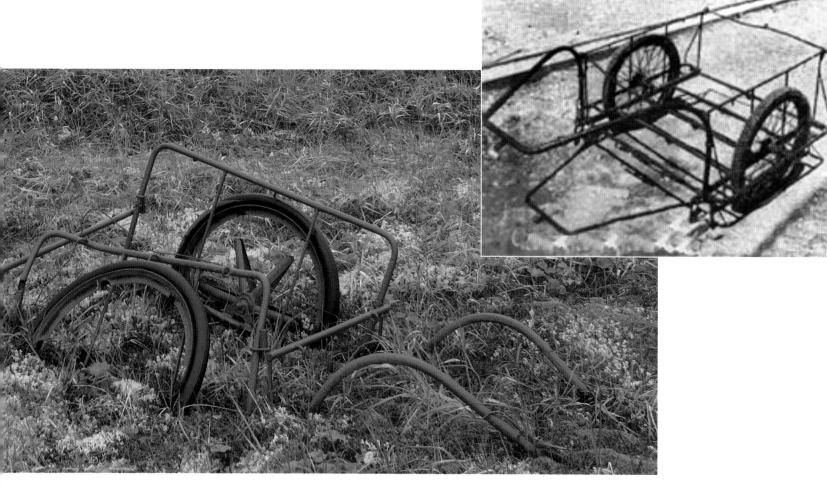

A collapsible construction cart. The Japanese tended to utilize hand power over mechanized construction.

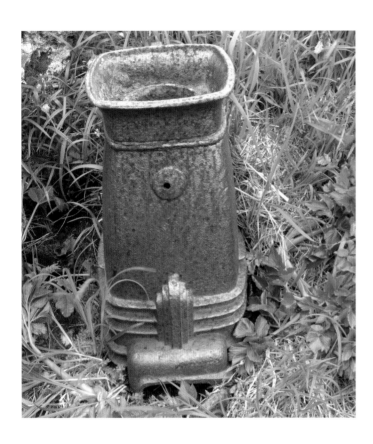

Right: Note the coal stove in the corner of this navy building at Kiska Harbor. Imperial Navy troops fared better than their army counterparts based at Gertrude Cove. UAF-1970-11-87, ALASKA AND POLAR REGIONS COLLECTIONS, UNIVERSITY OF ALASKA FAIRBANKS. SAN FRANCISCO *CALL-BULLETIN* COLLECTION, ALEUTIAN ISLANDS PHOTOGRAPHS, 1942–1948

Above: This same type of coal stove lies exposed to the Aleutian elements at Kiska Harbor. IAN L. JONES

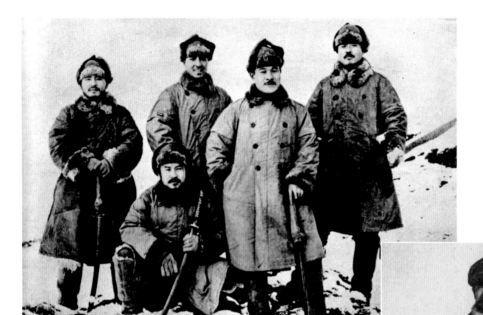

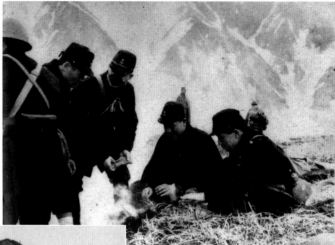

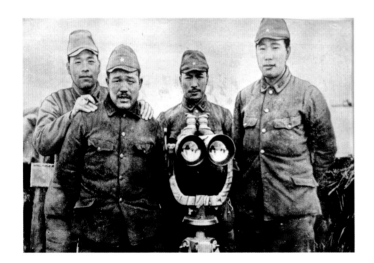

Top left: Fierce-looking Japanese soldiers. This photo was found amongst belongings when the Allies reclaimed Kiska. DEFENSE COMMAND ADVANCE INTELLIGENCE CENTER, NORTH PACIFIC COMMAND

Lower left: Japanese soldiers on Kiska. DAITOUA

Above: Naval Landing Party (Official branch) troops (Japanese Marines) in the Aleutians. DAITOUA, OCTOBER 1943

Lower right: Japanese soldier on Kiska. AUTHOR'S COLLECTION

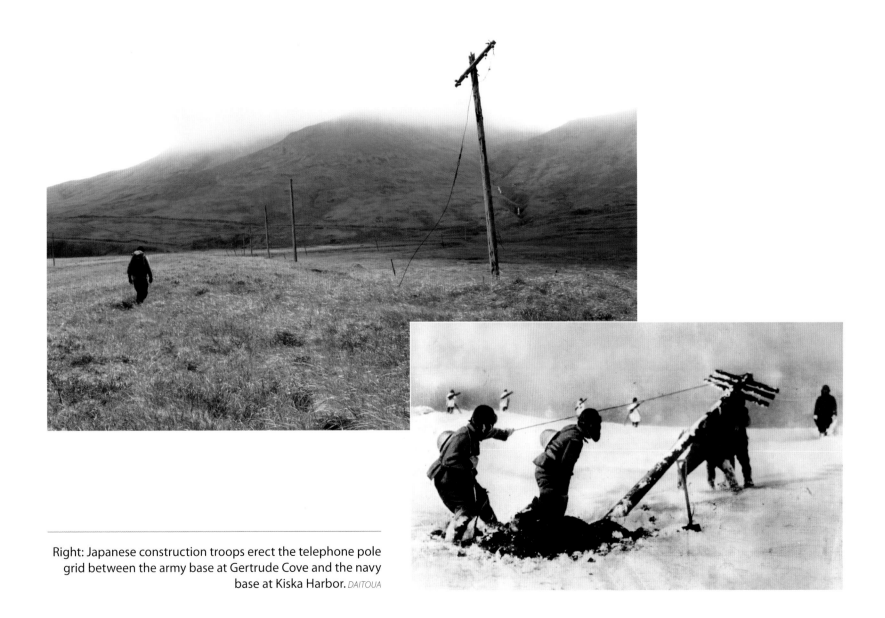

Right: Japanese construction troops erect the telephone pole grid between the army base at Gertrude Cove and the navy base at Kiska Harbor. *DAITOUA*

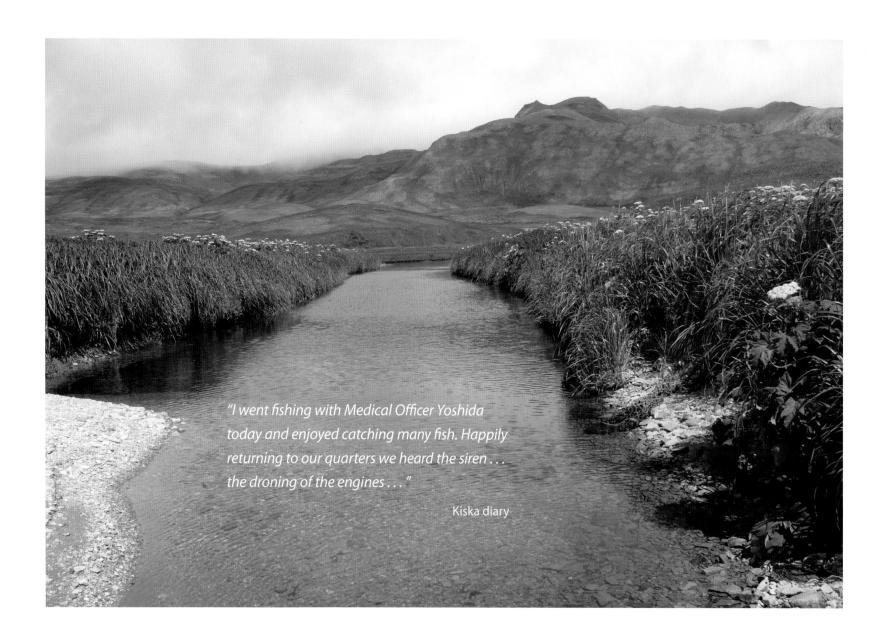

"I went fishing with Medical Officer Yoshida today and enjoyed catching many fish. Happily returning to our quarters we heard the siren . . . the droning of the engines . . . "

Kiska diary

DŌMEI TSŪSHINSHA, 1942, #10

DAITOUA

DAITOUA

Left: Salmon-bearing stream at Gertrude Cove is home to trout, seals, and aquatic birds.

Above and right: Japanese soldiers spent much of their free hours fishing to supplement rations and to pass the time. Our freshwater creek at Gertrude was home to trout and pink salmon but they wouldn't take a lure for us.

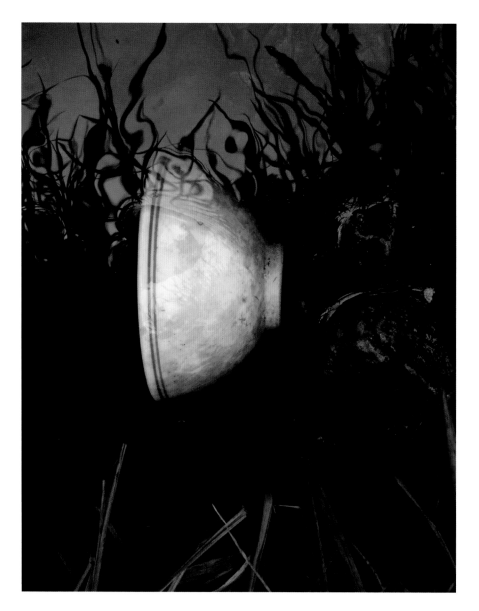

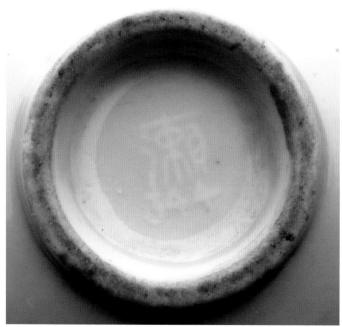

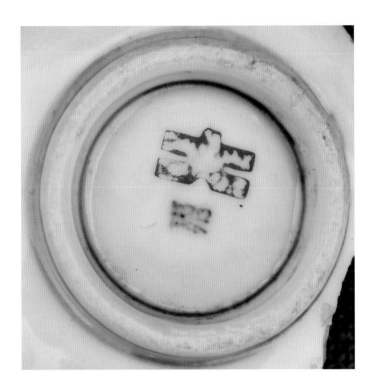

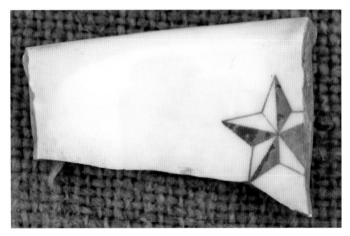

Above right: The Imperial Star of the Japanese Army on a bowl shard, likely from a wardroom for the officer class.

Below right: Oddly ornate chinaware considering Kiska was a war zone. These dishes betray the shortage of metals Japan was already suffering by the middle of 1942.

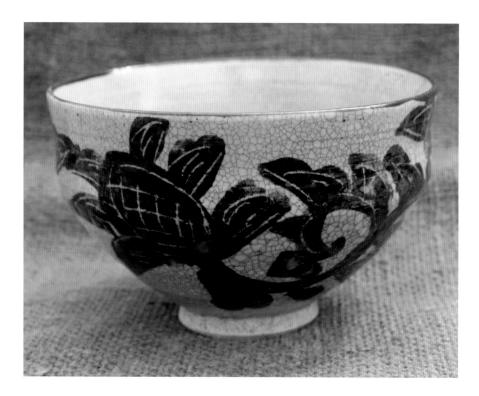

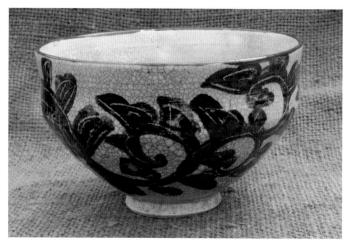

Above: Sea turtle design on a ceramic bowl.

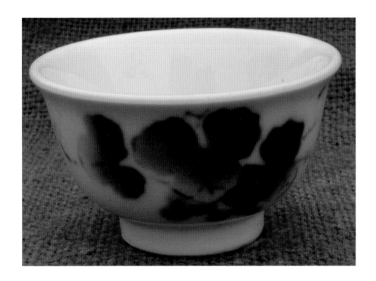

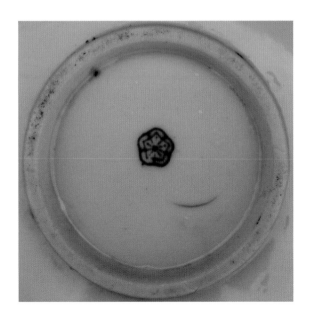

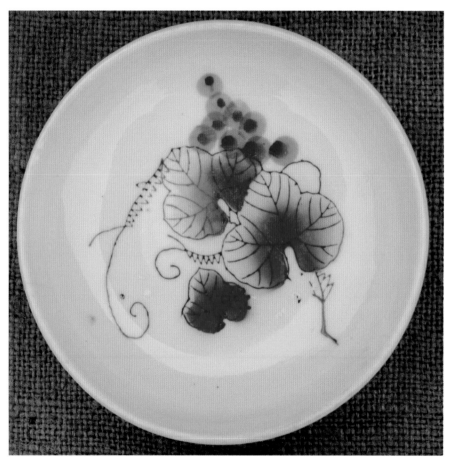

Left: The chrysanthemum—*kiku*—on the base of the sake cup is the symbol of the Imperial Japanese Navy. The flower is significant in Japanese culture as it represents the seat of the emperor's throne and is the symbol of the Imperial Navy.

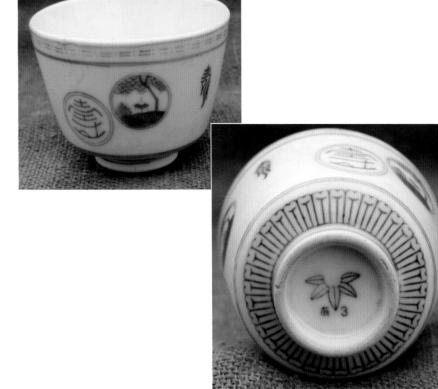

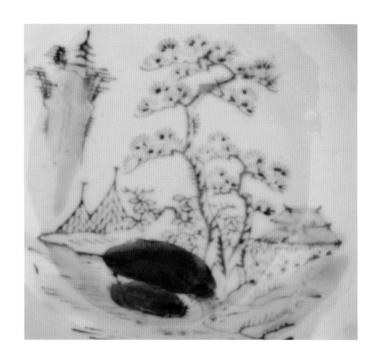

Above: Noodle or rice bowl.

Above right: Hand-painted pattern on a china plate found on Kiska. It was odd that such examples of finery existed in this remote battle zone.

Below right: Fine china saucer, part of a teacup set. The manufacturer, Noritake, is today still a producer of fine china.

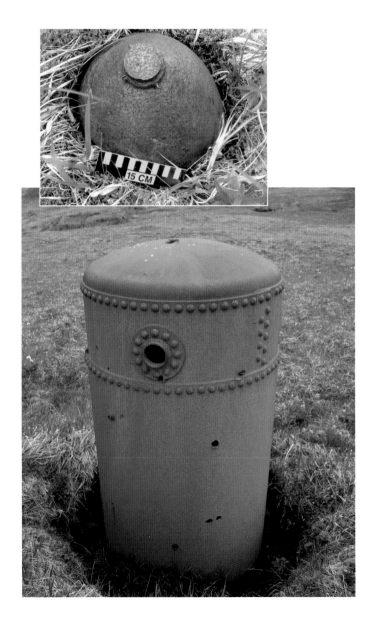

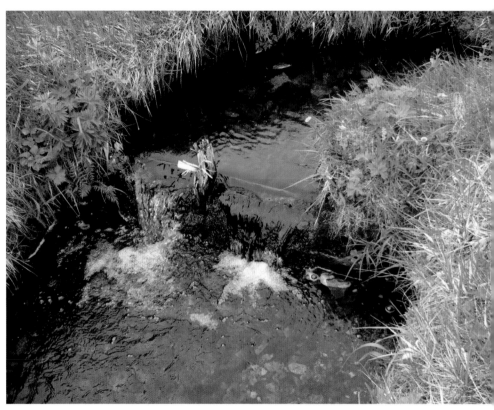

Above, left: Death from the sky. Japanese troops always had to be wary of attacks from the air and sea as evidenced by the five-hundred pound bomb fragment and the fifty-caliber bullet holes in the tank at left.

Above: One of many freshwater sluices at the army camp. The navy camp had a more intricate freshwater system with tanks, running water, hot water boilers, and fire hydrants.

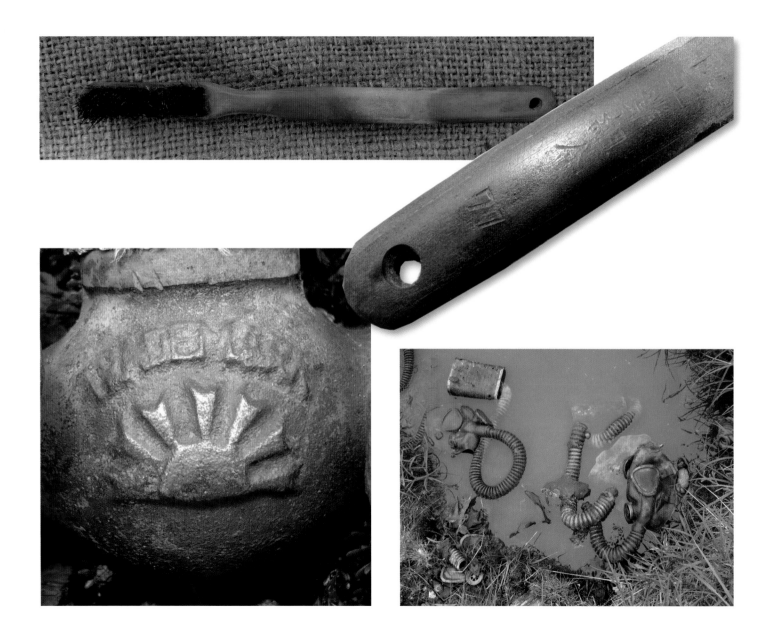

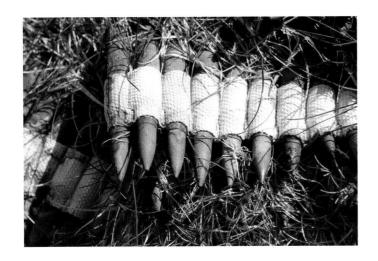

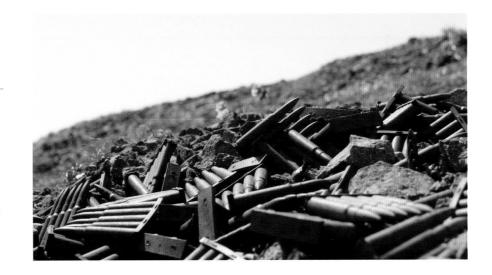

Opposite above: A tortoise shell and boar-bristle toothbrush.

Opposite below left: The Rising Sun on a valve.

Opposite below right: Faces of war.

Above: Discarded American machine gun belts.

Above right: Japanese gun manual slowly melts into the Kiska substrate.

Below right: Japanese 7.7 mm rifle clips.

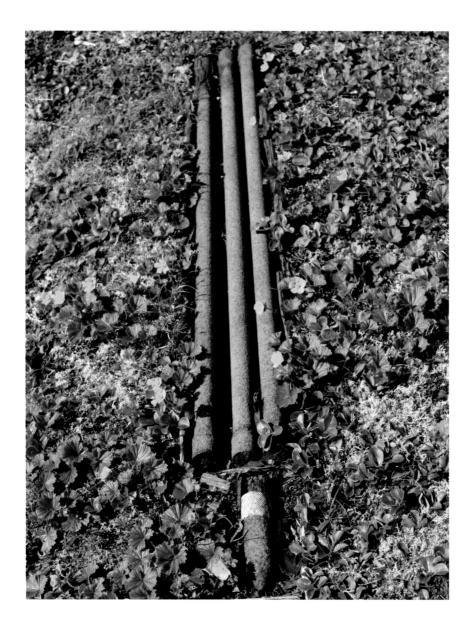

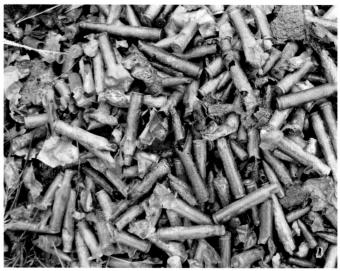

Above: Spent casings from a Japanese machine-gun site at Gertrude Cove. The shell casings had a Japanese character stamped into their base.

Left: A Bangalore torpedo and charge. These were used to clear barbed wire and other obstacles, and we found a few of these devices at a bunker site. Although this piece is likely American, the Japanese did have some Western manufactured weapons in their arsenal.

"None of us was a volunteer. We had all been ordered to our assignment. We were supposed to feel highly honored."

Ensign Kazuo Sakamaki, Type A submarine
pilot captured at Pearl Harbor

Six Ko-Hyoteki Type A midget submarines (Ha boats) arrived at Kiska in early July 1942 on the seaplane tender *Chiyoda*. Initially they were destined for deployment at Midway Atoll, but they were diverted to Kiska following the failure of the Midway operation. Armed with two forward-firing, eighteen-inch torpedoes, these boats had a single 600-horsepower electric drive motor powered by a bank of storage batteries that lined both sides of the control compartment. Their range was

over ninety miles at six knots and they could dive to one hundred feet. The two-man crew had no means to recharge the batteries at sea. There wasn't a single successful retrieval of one of these midget submarines following a combat sortie.

The midget submarine at the harbor, Ha-34, is the defining image of Kiska. Ill suited for the task of defending the harbor, the deployment of such submarines to the Aleutians was a knee-jerk reaction to the Midway loss. There are only six such intact examples of this boat in the world, including this wreck. Most portable items

Japanese submarine RO65 sunk at Kiska Harbor
September 28, 1942. JAPANESE NAVAL VESSEL *MARU* #43.
FROM U.S. NAVY FILE RETAINED AFTER THE WAR

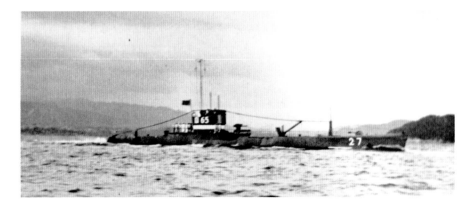

have been stripped away by souvenir hunters. One of the attributes in selecting submarine pilots was their small stature. When I squeezed my five-foot-nine-inch frame into the conning tower, it was a cramped fit with all of my layers of cold weather gear, and I couldn't imagine putting to sea in such a craft. Rusting and gradually sinking into muskeg, the remaining sub is being slowly consumed by the island. It is an example of the doubtful reasoning of Japan's ill-fated venture into Alaska. The boats were of little use at Kiska, with three written off due to a combination of weather and airborne attacks. The remaining three submarines were put out of commission with explosive charges set by the retreating Japanese. They suffered further destruction in Allied bombings of the island following the enemy evacuation. By June 1943 all Ha boats were out of commission and their crews evacuated to Paramushiro, the navy base in the northern Kuriles. Ha-34 is still intact but in a damaged condition in the area of the submarine shed. The other boats were cut up for scrap, and one hull portion remains on the beach and one in the surf zone near the marine railway.

The Kiska submarine base also supported missions of regular fleet submarines operating in the Aleutians. The submarine RO-65 sank in Kiska Harbor on September 29, 1942, after taking a direct hit during a bomber attack. One account of the sinking lists seventeen crewmen drowned, while a conflicting report records all hands lost. The submarine's commanding officer,

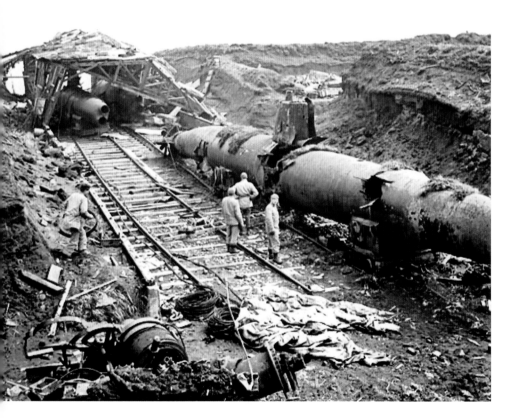

Left: The two-man submarine following the Allied reoccupation in August 1943 and the submarine today (right).
U.S. NAVY PHOTO

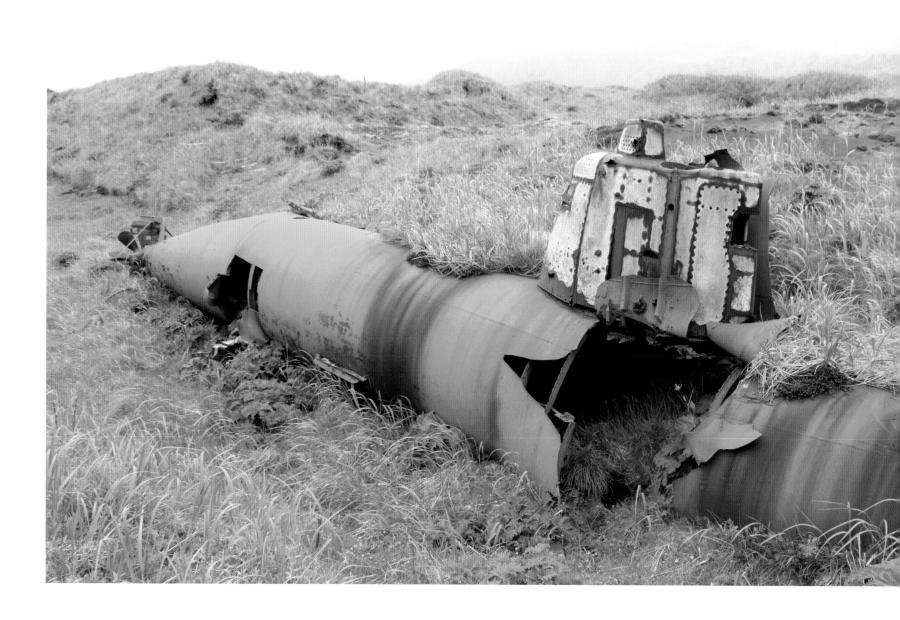

Lieutenant Shoichi Egi, was ashore during the loss of his ship. This class of RO boats were a post–First World War British-Vickers design submarine, sold abroad to foreign navies or built under license in foreign shipyards. RO-65 had been commissioned in 1924 at Mitsubishi Shipyard in Kobe. Outmoded by the start of the war, this type of submarine had been relegated to training and coastal patrol but was pressed back into service once the naval war began to turn against Japan. The Imperial Navy claimed RO-65's sinking was due to incorrect actions by the crew during the attack. An inspection by National Park Service divers in 1989 found the conning tower lying away from the hull and evidence of an explosion.

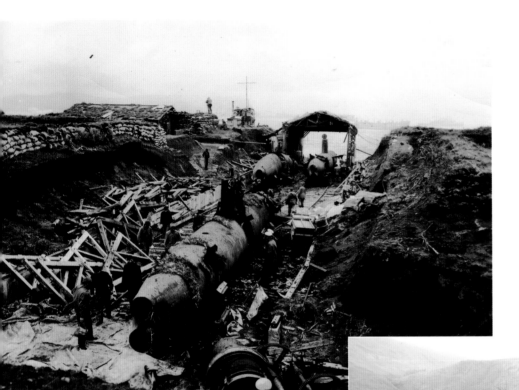

U.S. NAVY PHOTO

The large fleet submarine I-7 was also a casualty at Kiska. The Type J3 boat was assigned to the Northern Fleet under Lt. Commander Koizumi Kiichi in June 1942, and she took up duties patrolling the waters around Unalaska and Dutch Harbor. On July 14, 1942, I-7 sank the U.S. Army transport *Arcata*, which was on its way south to Seattle while transiting Unimak Pass, the strait separating Unimak and Akutan Islands. The sub was later assigned patrol and supply duty to Attu and Kiska, islands besieged by a cordon of U.S. Navy ships. In June 1943, I-7 ran afoul of the navy picket in confrontation with the American destroyer *Monaghan* while attempting to return to Japan with a large number of wounded and evacuees. The submarine was subjected to intense shelling after running aground at Twin Rocks off Vega Point at the southern end of Kiska. With fifty feet of bow still protruding above the water, forty-three crew and evacuees were rescued from the stricken submarine while eighty-three perished. Following the rescue, the Japanese dynamited the bow. While en route to Gertrude Cove on *Tiĝlax̂,* I had made a mental note to be on deck as we rounded Vega Point from the west. I felt pity for those

poor souls who suffered a terrible slow death marked in inches of dark, freezing water. No one would ever visit their graves in that lonely ocean. I wanted to make a quick remembrance in my head for those below, but I could only think of a line of a Shakespeare verse:

> Full fathom five thy father lies;
> Of his bones are coral made;
> Those are pearls that were his eyes:
> Nothing of him that doth fade

Ariel's poem from *The Tempest* seemed appropriate for this moment.

Right: Submarine interior. Note battery banks on both sides. Heavy metals contained in the battery cells could prove to be an environmental problem.

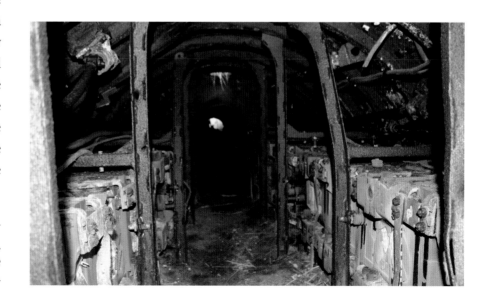

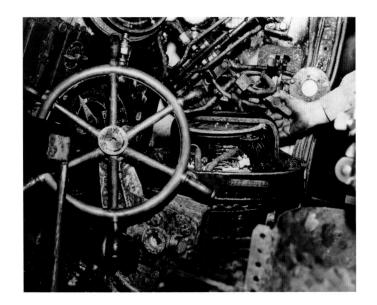

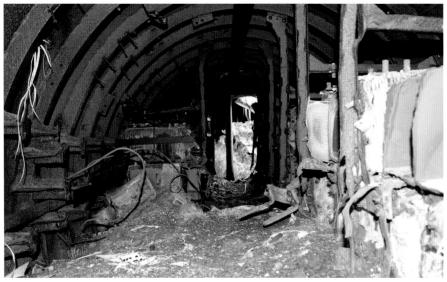

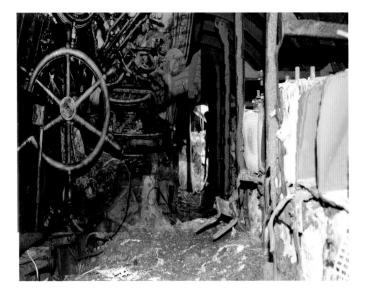

Within Kiska Harbor and its approaches are the victims of American submarine actions. On its first war patrol, the U.S.S *Growler* slipped into the harbor and sank destroyers *Shiranuhi*, *Arare*, and *Kajumi* in

Above left: Control room of the type A two-man submarine. these early photos are from a type A captured following the attack on Pearl Harbor, Hawaii. NAVAL HISTORY & HERITAGE COMMAND, WASHINGTON, DC, #91337

Above: The Kiska sub, port side. This is where the control room would be.

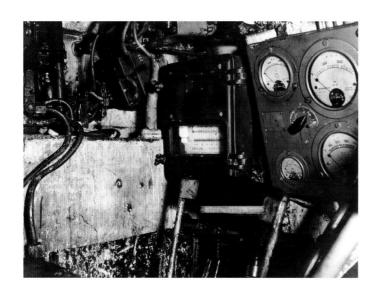

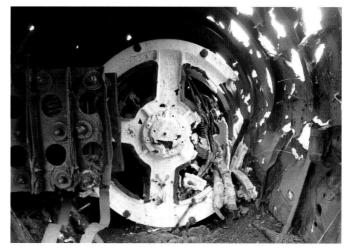

quick succession. The U.S. Navy's Gato-class submarine *Grunion* sank sub chasers CH-25 and CH-27 just outside the harbor. A few days later, *Grunion* was lost with all hands five miles west of Kiska. The wreck was

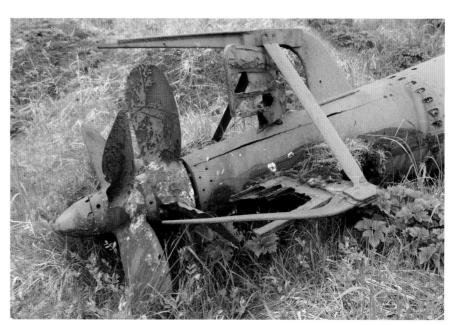

Above: The original interior of the type A. Note the battery forward of the instrumentation panel. NAVAL HISTORY & HERITAGE COMMAND, WASHINGTON, DC, #91336

Above right: The 600 horse power motor of the type A.

Right: The tail end of the submarine with counter-rotating propellers on Kiska today.

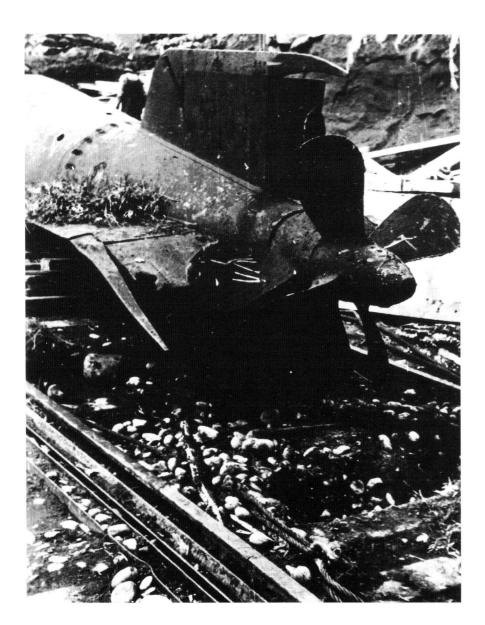

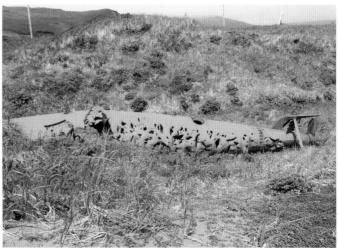

Above: The Ha boats suffered further damage from Allied strafing as evidenced in the tail section of this single surviving submarine.

Left: Counter-rotating propellers of the Ha boat. The retreating Japanese set demolition charges in the three surviving submarines. These boats were impractical in the North Pacific and had a poor war record all around. At the mercy of swells, the two-man crew would struggle hard to maintain periscope depth without breaking the surface. There was not a single successful retrieval of a Ha boat following a combat sortie. ALASKA DEFENSE COMMAND, ADVANCE INTELLIGENCE CENTER, NORTH PACIFIC COMMAND

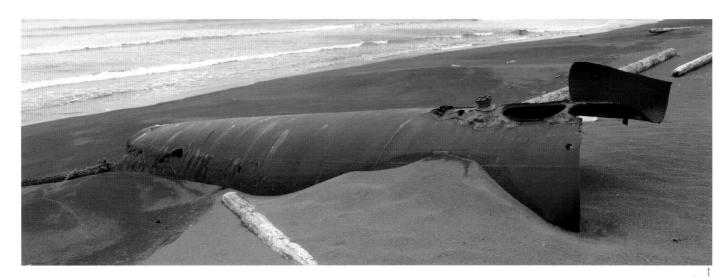

discovered in 2007 in the Bering Sea at a depth of 3,300 feet. Photos reveal the diving control planes in a sharp angle of descent. Speculation is that after firing a torpedo at a Japanese supply ship, *Grunion's* own torpedo circled back toward the submarine. Skipper Mannert Abele ordered a crash dive to avoid the hot-running torpedo. Possibly the diving planes, which control a submarine's

Right: One of the Ha boats being cut up for scrap, 1943.
PHOTO P430-24 ALASKA STATE LIBRARY, U.S. NAVY BUREAU OF AERONAUTICS, PHOTOGRAPHER'S NUMBER 5609

Above: The same sub rusting in the surf.

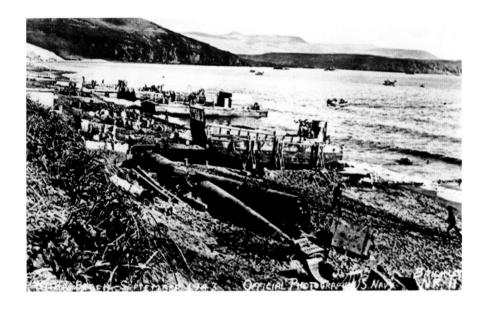

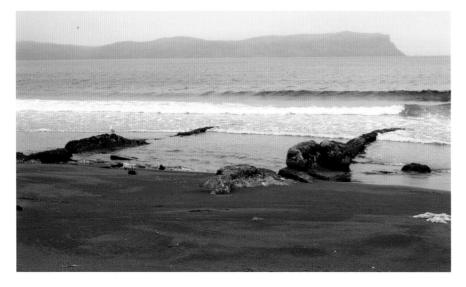

rate of descent, jammed in a thirty-degree dive. With no way to halt its steep plunge, the submarine would have imploded under the water pressure at the depth of one thousand feet.[8]

The *Nissan Maru* was sunk June 19, 1942, and is directly in front of the submarine base. I stood on the shore of the harbor at the site of the base and noticed a continual oil sheen and the slight smell of diesel wafting to the surface. *Nissan Maru* was a three-year old, 427-foot supply vessel sunk in the harbor when a B-17 Flying Fortress landed a thousand-pound bomb into the number four cargo hold. The vessel burned for several hours before sinking in ninety feet of water. When National Park Service divers surveyed the wreck and harbor floor in 1989, they found drums of fuel, trucks, and construction equipment still aboard the nearly intact wreck.

The remains of other Japanese transport ships remain partially above water around Kiska. *Urajio Maru* was originally the 3,072-ton British cargo vessel *Serbistan* when Kawasaki Kisen Kaisha Ltd. ("K" Line) purchased

Above left: Note the submarine hulls on the shore and the marine rail on the right side of the picture in the surf at landing craft. U.S. NAVY PHOTO

Left: The same area today.

it in 1926. The Imperial Navy appropriated the ship for the Aleutian triangle run, Paramushiro–Attu–Kiska. On December 30, 1942, the ship was damaged and four crewmen killed by bombs from B-24 Liberators that flooded the number one hold. In the midst of repairs the following January, a terrific storm caused the ship to drag anchor, and it ran hard aground on the harbor's north beach. It was used as a breakwater and storage facility by the Japanese but was a constant target of marauding planes. Today the main body center section has collapsed on itself and the bow and stern sections have become detached.

Nozima Maru was originally operated by the steamship company Nippon Yusen Kaisha (NYK Line), and it also was conscripted by the Japanese navy in 1941 and converted to a 7,190-ton troop transport. After unloading supplies, the ship was preparing to leave Kiska on September 15, 1942, when the harbor came under intense consecutive air attacks. Detonations holed the hull,

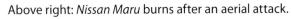

Above right: *Nissan Maru* burns after an aerial attack.
UAF-1970-11-71, ALASKA AND POLAR REGIONS COLLECTIONS, UNIVERSITY OF ALASKA FAIRBANKS. SAN FRANCISCO *CALL-BULLETIN* COLLECTION, ALEUTIAN ISLANDS PHOTOGRAPHS, 1942–1948

Right: *Urajio Maru* beached at the north side of the harbor.
U.S. NAVY PHOTO

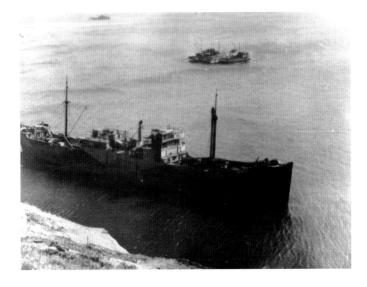

and the vessel was beached at the creek mouth of Trout Lagoon. Air attacks further damaged the ship, which was written off as unsalvageable in October. In 1956, the bow of the ship was removed and the remaining after-section refloated and towed back to Japan. This salvaged portion sank, however, in a storm off the Japanese coast. All that remains of *Nozima Maru*'s story is this rusting and beached bow section.

Walking in the area of the harbor was easier due to the grading and construction done there, including a football-field-sized cement pad that was the submarine base workshop. It was a welcome feeling to walk on a man-made surface. We climbed the road around the harbor as it wound up behind Trout Lagoon, around Mercy Point to the seaplane base, and on to North Head. We had seen several days of heavy rain, and a dirt slide covered the road under Mercy Point. A softball-sized hole in the cliff face revealed a long covered tunnel bored into the bluff, with the hangers for string lighting still in place. I badly wanted to go farther into the tunnel, but we had no means of testing the air quality—a special concern since the tunnel had been blocked for some seventy years. We hiked on. Above us was a twin 25 mm machine gun that once threw up deadly fire at Allied planes. The slope was slick, and while cutting across it I slipped, with my full body weight coming down hard on my left ankle. It was a six-mile hobble through hill and swamp to our spike camp at Sargeant's Cove. I spent a painful, fitful night dreading the long trek home to Gertrude Cove.

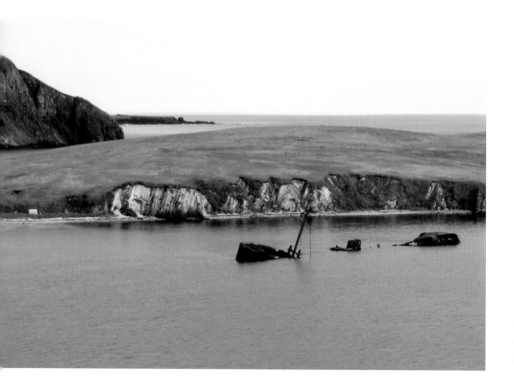

The *Borneo Maru*. Our camp can be seen to the left of the wreck.

Morning broke gray and overcast, and I started out at nine o'clock while the professor broke down the spike camp. He fashioned a splint for me out of backpack straps and the old standby, duct tape. The spike camp would be packed up and retrieved when we were picked up about ten days later. It was another five linear miles to base camp but closer to eight with the requisite fording of creeks and towering hills—all the more difficult because of my injury. I estimated I would reach Gertrude Cove at about five PM. The fog dropped to less than six feet above ground level and I had to stoop to stay under it. The batteries of my GPS died, but I had my compass as a backup. Kiska lies almost directly north–south, so I could maintain a relative idea as to my position. My compatriot caught up to me and showed me a *sake* bottle he had found in a dugout. But I had lost my inclination for exploring; my only thoughts were of getting back to base camp and resting my injury, since the swelling strained the confines of my boot.

Stopping to rest, I wolfed down an energy bar and lay back into the ground cover, drifting off despite a light

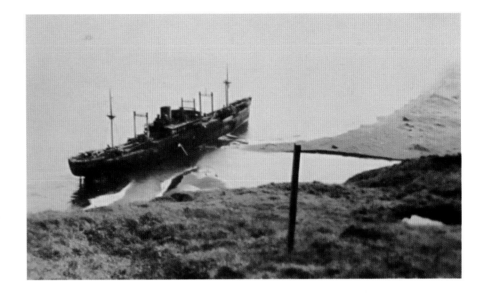

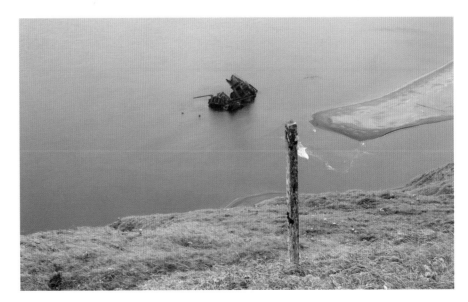

Above: *Nozima Maru* beached at Trout Lagoon. U.S. NAVY PHOTO

Below: All that remains of the ship today.

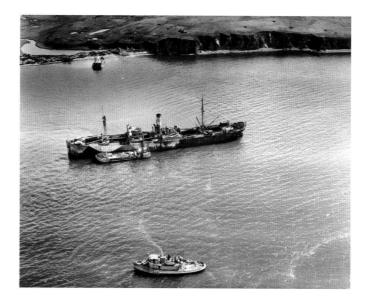

rain drumming on my face. Overhead I heard the faint roar of a jetliner on its way to Asia. I contemplated those executives in business class, comfortably sipping martinis and watching an in-flight movie. The rain turned into a downpour and startled me out of a semiconscious nap. I was still on Kiska. And they had no idea that I was 35,000 feet below them in pain, exhausted, hungry, and unwashed—a wretched castaway in a Jack London novel. The rain ran down my face and collected in my hood, spilling down my back inside my foul weather jacket as I sat up. About five hours still to go.

The weather let me off lightly and cleared. In the far distance, the broken outline of *Borneo Maru* was an uplifting sight. After eight hours I stumbled into base camp exhausted and annoyed at myself. I had taken great pains to avoid a sprain in the rutted topography, but one stupid move had caused me so much pain and ended my hiking days on Kiska. Fortunately, there were only about nine days left, and a good portion of those would be spent breaking down the base camp and preparing to leave.

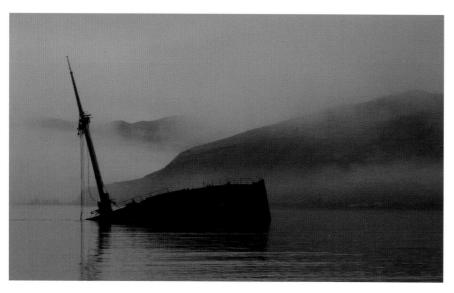

Above left: The *Borneo Maru*, 1943. P430-88 ALASKA STATE LIBRARY, U.S. NAVY BUREAU OF AERONAUTICS, PHOTOGRAPHER'S NUMBER 346-1

Left: The *Borneo Maru* today.

My forced confinement to camp left me time to contemplate the broken hulk of *Borneo Maru*, the Japanese army transport ship damaged by bombing and then beached at Gertrude Cove directly in front of our camp. Viewing the wreck daily, combined with our long sequester, added to the feeling that we really were shipwrecked on that far-flung island. I considered *Borneo Maru*'s unhappy conscription. Originally the vessel was laid down as a 5,863-ton passenger ship at Kawasaki Shipbuilding in Kobe in 1917. Osaka Shosen Kaisha (OSK) Line operated the ship on its run from Kobe to Tacoma, Washington, until the Imperial Army requisitioned the ship in 1941 and converted it to a troop transport. Initially the ship supplied the Japanese army in China and Indochina and took part in the invasions of Siam (Thailand) and the Philippines. In June 1942 the ship was assigned to support operations in the Aleutians and participated in the occupation of Kiska. In October 1942 *Borneo Maru* left the port of Otaru bound for Kiska with a manifest of 4,546 sacks of rice, 7,397 bottles of sake, 1,239 sacks of charcoal, 1,250 bags of cement, 21,200 units of coal, 365 boxes of ammunition, and four antiaircraft guns. The ship also carried a company of machine gunners,

twenty-three radio operators, seventy members of an engineering battalion, and 180 antiaircraft gun crewmen.

Off Attu, reconnaissance planes from the Eleventh Air Force detected the ship. Three B-24s were dispatched to sink the vessel but were driven off by the ship's three antiaircraft guns. Slightly damaged, the vessel approached Kiska by October 6 and began offloading cargo for the army at Gertrude Cove but again came under attack from aircraft. In an attempt to save his ship, Captain Wada Noguchi ran his ship aground and beached it in

Kamchatka fritillary (*Fritillaria camschatcensis*)

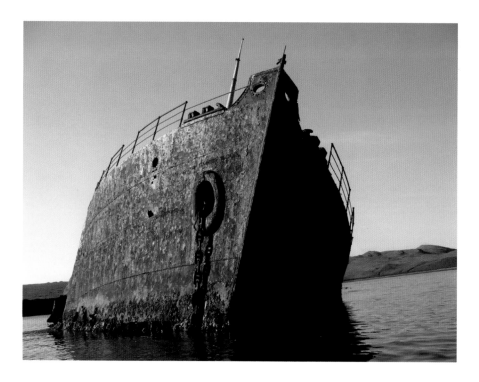

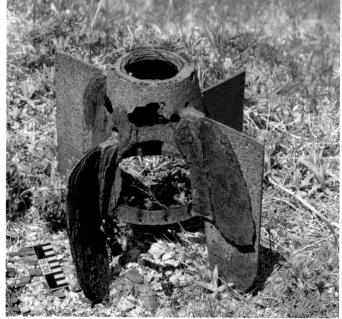

Above: The Japanese army transport *Borneo Maru* at Gertrude Cove.

Top right: An interior explosion within the hull is evidenced by the outward curling of the hull plates.

Bottom right: Tail section of a USAAF MK 13 aerial torpedo from the beach at Gertrude Cove.

Opposite: An American bald eagle sits atop the mast of the *Borneo Maru*.

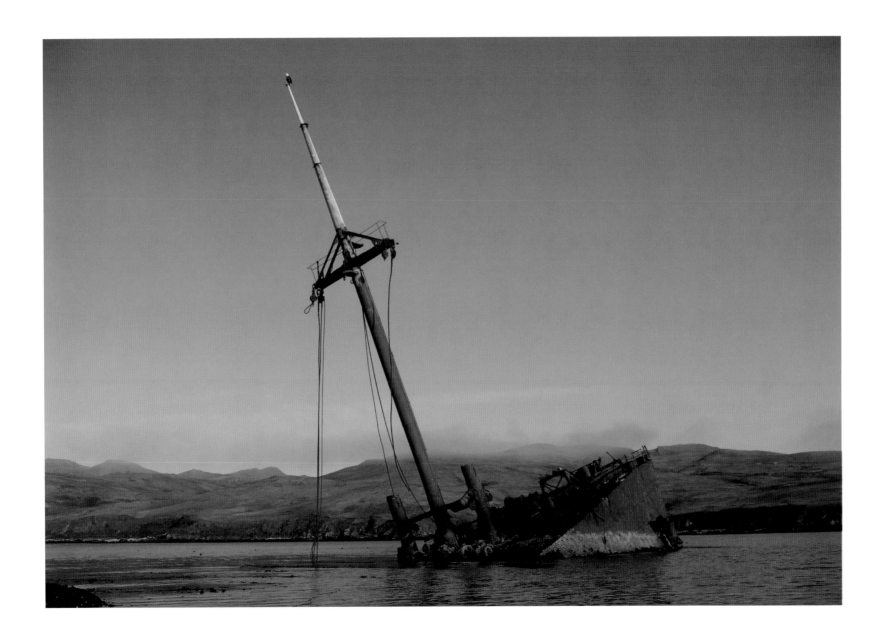

the shallows about one hundred yards from shore. Two crewmen and two soldiers were killed by repeated strafing. On October 15, B-26 Martin Marauders of the 73rd Bomber Squadron armed with aerial torpedoes tried to finish the ship off, but the torpedoes proved useless in the shallow water and all failed to connect. One torpedo reportedly missed the ship and ran up on the beach and exploded. Near shore, we found the tail section of an M-13 torpedo, the type carried by U.S. aircraft. A

B-26 plane, number 40-1478 commanded by Lieutenant Ralph D. O'Riley, was hit by flak from a Japanese destroyer while lining up the transport for a torpedo run. The plane blew apart and disappeared into the waters of Gertrude Cove, killing O'Riley, his co-pilot Lt. John E. Joyce, Sgt. Edward J. McCallick Jr., and Cpl. William F. Moran.

I kayaked out to *Borneo Maru*, one of her rare visitors. A common eider with ten ducklings and a curious harlequin duck paddled in and around the wreck like children run amok. It was hard to imagine the intense and protracted carnage that took place in this serene bay seventy years ago. Water washed in and out of the broken hull, and two holes with the metal bent outward were evidence of explosions from inside the hull. On a calm day when a mild breeze blew over the wreck, I could hear a faint tune like that of a Japanese flute. I had thought the sound was the result of the constant wind's assault on my hearing, but it turned out to be the gentle breeze passing over water-filled pipes. Like blowing into a soda bottle, it made for a strange little melody, almost Japanese in nature and audible on only the calmest days.

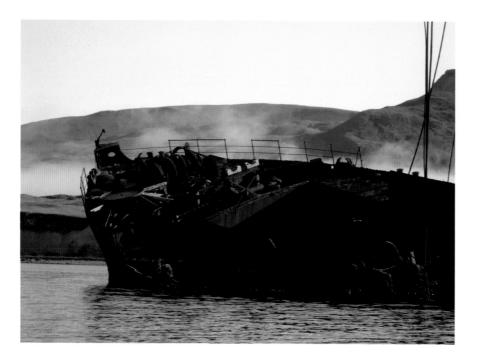

Detail of the bow section of the *Borneo Maru*. I had the fortune of kayaking out to the wreck on a rare sunny day.

The Gods Have Forsaken Kiska

"... what is to become of us?"

Japanese diary found on Kiska

Despite all of the desolation, the bombings, the losses of men and aircraft, and the constant threat of death from above, the Japanese remained firmly entrenched on Kiska's cold, bleak hills. By the end of 1942, the U.S. Navy established a warship cordon west of the Japanese-held Aleutians that virtually strangled the supply route to the islands. With the development of the Amchitka base in early 1943, fighters and bombers could carry out patrols of these same waters virtually unchallenged. In January 1943, an American B-24 Liberator aircraft sank the transport *Kotohiro Maru*, approaching Attu. The *Montreal Maru*, carrying a load of heavy road-building equipment destined for the unfinished airstrip on Kiska, was sunk by a lone PBY flying boat. On February 18,

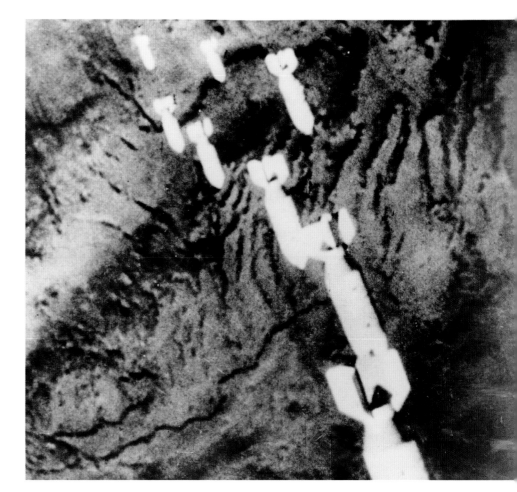

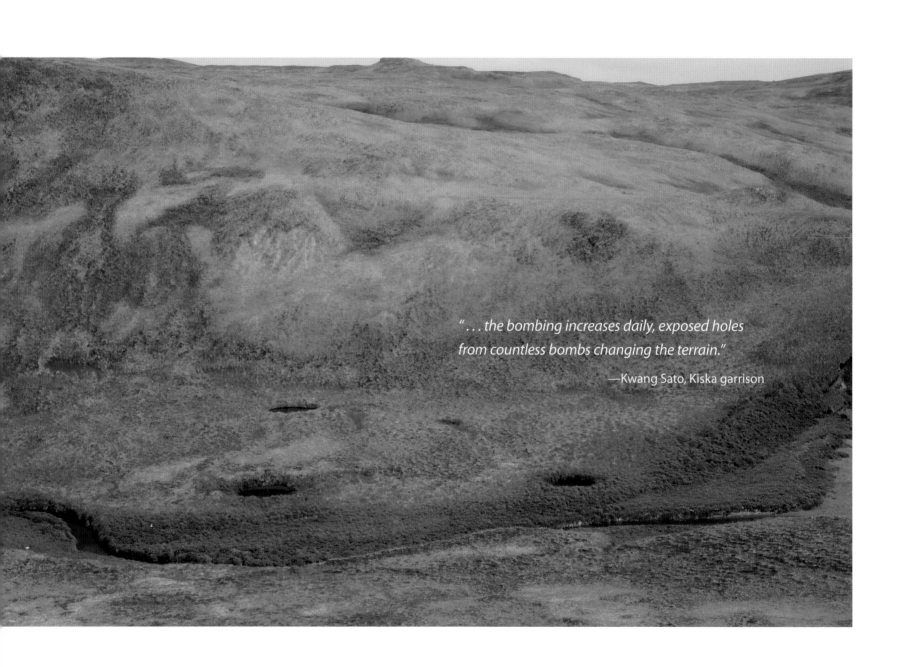

"… the bombing increases daily, exposed holes
from countless bombs changing the terrain."

—Kwang Sato, Kiska garrison

1943, the *Akagane Maru* was sunk in these same waters by the heavy cruiser *Indianapolis* after delivering a platoon of troops and cargo to Attu. In the following weeks, the blockade forced a dozen more vessels to turn back to Japan.

Lieutenant General Kiichiro Higuchi prevailed upon the Imperial Navy to challenge the blockade in order to relieve his beleaguered Alaska garrisons. A veteran of the Chinese border skirmishes with Russia in the 1930s, Higuchi commanded all land forces of the Northern District Army, including the Aleutian garrisons. Earlier in his career, Higuchi served as a military attaché in Berlin, where he was openly appalled at the Nazis' treatment of Jews. In 1938 he commanded a division in Harbin, Manchuria, and while serving there allowed 20,000 Russian Jews to cross over the border from the Soviet Union, providing food and security for the European exiles.[9]

Rear admiral Boshirō Hosogaya vowed to smash through the American blockade and on March 26, 1943, engaged Admiral Charles McMorris' cruiser squadron south of Russia's Komandorski Islands. The four-hour

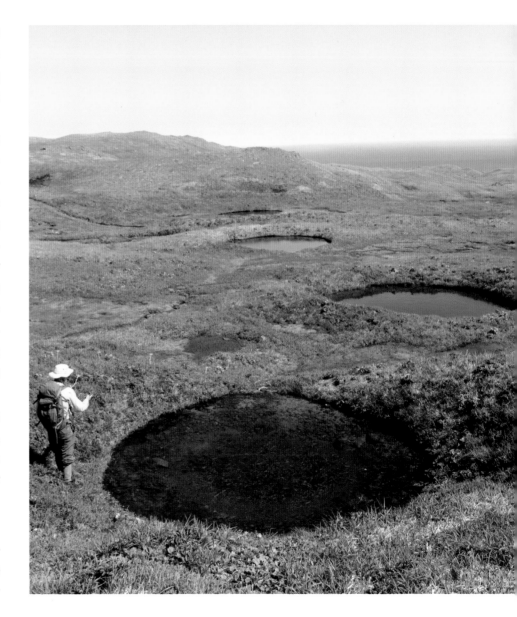

Opposite and above: Bomb craters in the fragile oceanic substrate.

artillery duel of navy cruisers was the longest and last big ship duel in modern naval warfare and succeeded in turning back the Japanese fleet while keeping the

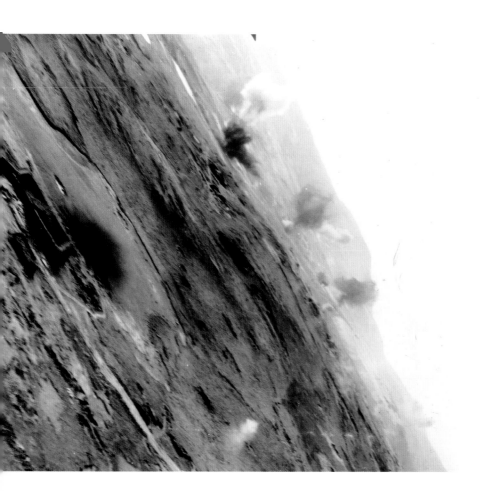

Left: American bombs exploding in the runway.
USAAF STRATEGIC BOMBING SURVEY

blockade intact. Other than the occasional submarine that managed to slip past the blockade, Japan's Alaska possessions were virtually cut off. With the supply line cut, so too went the letters and small packages, the only connections to family across the sea.

A frantic banzai charge led by Colonel Yasuyo Yamasaki on May 29, 1943, ended nineteen days in hell as Attu fell to American troops trying to wrestle the island away from its stubborn Japanese defenders. Yamasaki had withdrawn his troops into the mountains of Attu rather than confront the enemy on the beach. The Japanese strategy caused the Americans to fight for every foot of ground in a battle predicted to take just three days, but that dragged to nearly three weeks. The Japanese strategy of withdrawing into well-defended positions and forcing the enemy to come to them became the benchmark tactic repeated throughout the campaigns of the South Pacific. Except for the twenty-eight Japanese taken prisoner, the entire Attu garrison of 2,350 imperial soldiers was lost in service of the single-minded ideal of holding Attu at all costs. On the American side,

549 were killed, 1,148 were wounded in action, and 2,100 suffered noncombat injuries. I interviewed several infantry veterans of Attu who went on to fight in Leyte and Okinawa. They recalled the misery of Attu as their worst experience of the war.

With the American occupation of Attu in hand, all resources could be brought to bear against the Japanese on Kiska. An Allied invasion was scheduled for August 1943, and efforts to wear down the Japanese were ramped up. Navy guns pounded the island with great broadsides. Allied aircraft subjected Kiska to terrific bombing and strafing runs with every break in the weather, dropping 181,000 pounds of explosives in one twelve-hour period alone. An assault force of 35,000 Allied troops amassed on Adak, poised for an amphibious assault. Huddled in knee-deep water of a dank tunnel, the tenacious spirit of the Japanese soldiers dimmed as the ground reverberated with each explosion. Anticipating

the same fate as his compatriots on Attu, Japanese soldier Kishichiro Miyazaki wrote, "All is lost . . . the Gods have forsaken Kiska."

Right: A Canadian-American taskforce involving 35,000 troops heads to Kiska in Operation Cottage, August 15, 1943. Allied casualties were expected to be seventy-five percent in view of the tenacious fight the Japanese put up on Attu.
PHOTO U.S. NAVY

An Enemy Vanished

Commandos of the First Special Service Force (FSSF), a joint unit of Canadian and U.S. paratroopers on their first mission, paddled silently ashore in the early hours of August 15, 1943. A joint Canadian-American amphibious combat force of 35,000 troops waited offshore to land on Kiska's western beaches. Casualty ratios were expected to meet or exceed those of Attu because of the well-entrenched defensive positions on Kiska. Assessments of enemy strength ran as high as nine thousand desperate and suicidal Japanese troops who were expected to follow the same strategy used at Attu and die defending Kiska for the emperor. In light of the tenacious Japanese resistance on Attu, planners of the Kiska invasion estimated Allied casualty rates would reach seventy-five percent. Although pilots had reported no movement on the island for several weeks, it was believed the Japanese were hiding in tunnels awaiting the final assault.

In the end, the Kiska invasion was anticlimactic. The FSSF commandos reported no sightings of Japanese, and following the all clear the main force came ashore in dense fog. As individual units made their way overland toward Kiska Harbor, the far-off sounds of machine gun fire and shouting coming through the fog seemed to indicate that the enemy had been found. Tragically, Allied troops engaged each other in a firefight in the disorientating fog. Twenty-one American and four Canadian soldiers were killed by friendly fire, accidents, and mined traps on Kiska. As it turned out, the Japanese were nowhere to be found. Unbeknownst to the Allies, when the American navy's blockade ships withdrew for seventy-two hours to rearm and refuel, eight ships of a fifteen-ship convoy evacuated 5,500 Japanese troops from Kiska within hours. The evacuation was an amazing Japanese success in an otherwise cheerless operation. The destroyer U.S.S. *Abner Read* struck a mine on August 18, killing seventy-one and bringing the Allied campaign to reclaim Kiska to a miserable end.

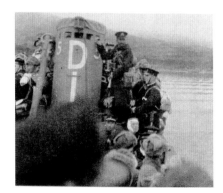

Some five thousand troops evacuated Kiska July 28, 1943. SHOGUCHI YASUHRO

Journey's End

I turned in my sleep and the pain in my ankle shocked me awake, although the discomfort was greatly tempered. The previous night's radio call confirmed *Tiĝlax̂* would pick us up on August 7, in three days. Onboard *Tiĝlax̂* would be hot showers, splendid meals with fresh vegetables and fruit, rich desserts that I would never indulge in at home, and endless amounts of strong coffee. Even so, it would take another three days to get home and a stint of sleeping overnight in the Anchorage airport.

Dawn breaks very late at this latitude in late summer, and since our watches were set to Adak time, it was still too early to get up.[10] I listened to the absence of wind and rain. It promised to be a calm day. Outside of my tent was only the solitude of Kiska—the restful lapping of waves against a pebble shore punctuated by the lively bickering of merganser ducks in the creek marsh.

How remarkable, the evocative chirping of songbirds against a silent backdrop; at home such peaceful avian scales are overwhelmed by the relentless din of civilization. Although I was eager to be going home, Kiska had touched me forever. Regrettably, it is unlikely I will ever have the chance to return.

Kiska is a contradiction, a place of astonishing vistas surrounded by a blue Pacific, yet it will always be remembered for its place in the brief but fascinating Aleutians war. Underscored by the difficult weather meted out to both Axis and Allied forces, the Kiska campaign was a pivotal moment in Alaska's peculiar history. [11]

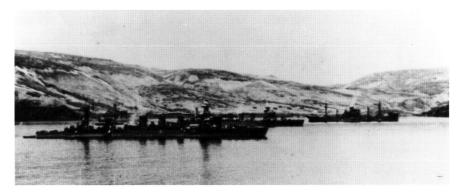

Japanese navy ships in Kiska Harbor. AUTHOR'S COLLECTION, PHOTOGRAPHER UNKNOWN. LIKELY FROM *DŌMEI* OR *DAITOUA*, NEWS PUBLICATION OF THE MILITARY THAT CONTROLLED INFORMATION GOING IN OR OUT OF JAPANESE WAR ZONES

"I want to go back to Japan . . . I want to get close to Japan . . . even by just one step."

—Hirano Kizo, wireless operator,
Imperial Japanese Army, Kiska garrison

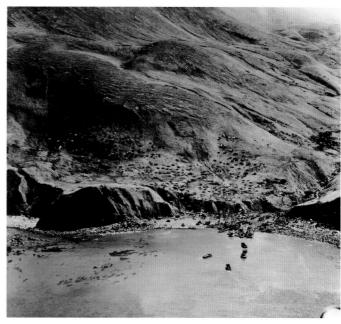

Above: U.S. and Canadian troops swarm ashore in Operation Cottage, August 15, 1943, only to find the more than five thousand men of the Japanese garrison had abandoned Kiska two weeks before. PHOTO U.S. NAVY

Left: Kiska—natural water garden.

Acknowledgments

Kiska is possible due to the efforts of many people who truly wanted to see this book published as much as I did. For their invaluable contributions: John Haile Cloe, author and historian, for many hours reviewing the book, supplying photos, and imparting your knowledge; Dr. Jim Rearden, author, historian and all-round Alaska legend; Melanie Arnis, who burned the midnight oil repeatedly editing the manuscript for me; James Engelhardt and Sue Mitchell of the University of Alaska Press for stick-handling the project through to fruition; Janis Kozlowski and Janet Clemons of the National Park Service for your input and endorsements; Justin Fulkerson of the University of Alaska Anchorage's Alaska Natural Heritage Program for plant identification; and most sincerely, Professor Ian Jones of Memorial University and Debbie Corbett of the Alaska Maritime National Wildlife Refuge, for helping me realize my dream of finally getting to Kiska.

I thank you all! *Arigatō* ありがとう

The author wishes to thank the following organizations for their support of this project:

The Alaska Humanities Forum
University of Washington
University of Alaska Fairbanks
Alaska State Libraries

Overlay image; photographer unknown

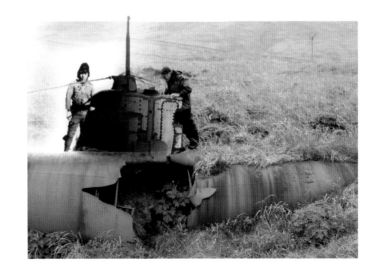

Notes

1. The biology professor requested that I not use his name or that of his affiliated university in any media.

2. The Aleut Corporation is one of thirteen Alaska Native Regional Corporations created under the Alaska Native Claims Settlement Act of 1971 (ANCSA) in settlement of aboriginal land claims.

3. Georg Wilhelm Steller, *Steller's Journal of the Sea Voyage from Kamchatka to America and Return on the Second Expedition 1741–1742* (New York: American Geographical Society, 1925), page 121.

4. Helen Wheaton, *Prekaska's Wife* (New York City: Dodd, Mead and Company, 1945), 172, 183.

5. Presumably the Type-B submarine I-25, which did three patrols of the North American West Coast. From Jim Rearden, *Forgotten Warriors of the Aleutian Campaign* (Missoula, MO: Pictorial Histories Publishing Company, 2005), 17.

6. Attu was reoccupied starting October 29, 1942, by a contingent of 2,300 soldiers of the 89th Infantry Battalion. The 303rd Independent Infantry Battalion arrived January 28, 1943, with the remainder arriving on February 2, 1943. The navy was represented by five hundred marines of the Japanese Naval Landing Force.

7. Robert K. Wilcox, *Japan's Secret War* (New York: William Morrow & Company, 1985).

8. Attack Analysis of Grunion Sinking by Commander Aiura (retired): http://ussgrunion.com/blog/attack-analysis/ and "*Grunion* (SS-216), Hypotheses of the Sinking," Don McGrogan, accessed Nov. 6, 2012. http://www.navsource.org /archives/08/08216e.htm.

9. Following Japan's surrender, Soviet leader Joseph Stalin demanded the extradition of Higuchi so he could be tried. On receiving word of this, the World Jewish Congress quickly formed a lobby directed at the supreme commander of the Allied Powers, General Douglas MacArthur, to prevent Higuchi's extradition and trial.

10. Standard time is skewed on Kiska, which remains within the same time zone as Adak (Anchorage minus one hour). Kiska should be in the next time zone west of Adak; however, the International Date Line jogs around the western Aleutians, leaving Kiska on the same time as Adak. This made for sunrise much later in the morning and sunset near 11 PM.

11. There are very few photos of the Japanese time on Kiska. I believe this is in part due to the displacement of troops after the evacuation. Navy and army troops that were part of the northern force would later have been assigned to northern China, the Japanese portion of the Sakhalin Island, and the Northern Kuriles. After declaring war on Japan in the final days of World War II, the Soviets swept into these northern regions, capturing tens of thousands of Japanese troops. These prisoners languished for years in the gulags of the USSR, and many never returned.

Index

Page numbers in *italics* signify illustrations.